ABANDONED
NORTH & SOUTH
MEMPHIS

WHAT'S LEFT BEHIND

NATASHA RAWLS

AMERICA
THROUGH TIME®
ADDING COLOR TO AMERICAN HISTORY

America Through Time is an imprint of Fonthill Media LLC
www.through-time.com
office@through-time.com

Published by Arcadia Publishing by arrangement with Fonthill Media LLC
For all general information, please contact Arcadia Publishing:
Telephone: 843-853-2070
Fax: 843-853-0044
E-mail: sales@arcadiapublishing.com
For customer service and orders:
Toll-Free 1-888-313-2665

www.arcadiapublishing.com

First published 2021

Copyright © Natasha Rawls 2021

ISBN 978-1-63499-318-0

Typeset in Trade Gothic
Printed and bound in England

CONTENTS

About the Author **4**

Introduction **5**

1 Abandoned North Memphis **8**

2 Abandoned South Memphis **35**

3 Honorable Mentions **83**

Acknowledgments **95**

Resources **96**

ABOUT THE AUTHOR

NATASHA RAWLS, AKA NaJo (Nāy-Jōe), is a multi-published, award-winning artist born in Little Rock, Arkansas, now residing in Cordova, Tennessee. Her talent as a photographer is influenced by her years as a sketch artist and fashion designer. Natasha is also an author of three romantic fiction novels that won Textnovel.com Editor's Choice: *The Fifteen-Year Itch*, *Scratched: The Sequel of The Fifteen-Year Itch*, and *The Relationship Contract*. Her photography has also garnered recognition in numerous magazine publications, with the largest being *Shutterbug Magazine* in their April 2018 issue. She is also mom of three children.

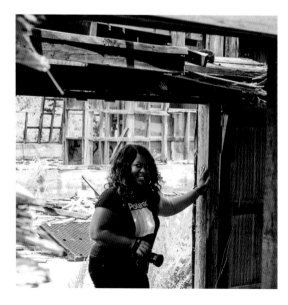

Me, doing what I love most!
[*Paul Harris*]

INTRODUCTION

I have been drawn to derelict abandoned buildings since I was four years old, going shopping in dying 1977 downtown Little Rock, Arkansas, with my grandmother. I was both frightened and intrigued by the tall, dark, desolate storefront windows. I would get a sort of rush from putting my face closer to the dusty glass and seeing the overwhelmingly immense and dimly lit spaces inside. I would pull away quickly afterward, as it gave me such an eerie feeling seeing something so large and unoccupied. I think this was where my megalophobia started, or it may have been that time I got lost in a giant Magic Mart store during closing time at about the same age, but now I feel compelled to explore these sorts of places, despite my intense fear of them.

What especially drives me to exploring abandoned structures is the curiosity of who lived there. When? What did they do? What was their life like? Why did they leave so much behind? How could they leave such a beautiful home or seemingly bustling business to rot? What happened?

One of my first explorations was with a group of friends a little over twenty years ago. None of us had cell phones or cameras. We just liked going into abandoned homes and exploring, taking nothing away with us unless it was placed on the curb for anyone to pick up.

It was a once-decent grey brick single-story home in a not-so-good area near the governor's mansion in Little Rock. I'll never forget that damp smell it had, yet none of the floors were weak, nor were there any collapsed ceilings—just lots of peeling paint and wallpaper with strange internal architecture that didn't look anything as ordinary as the outside of the house did. For example, the bathtub in the master bedroom area had a large dome over it that was built into the wall. I remembered

thinking to myself I could not live there because of that detail. It was too large and overwhelming. It began to trigger that old megalophobia. At that time, I did not know what this strange fear in me was called, but it was there. In my situation, it can start a panic attack or a hallucination during which I begin to feel as if the building will collapse over me. I know it's irrational, but that's how it feels. Yet, I keep exploring.

When it was time for us to leave this house, I pushed on the wrought-iron security door to exit and it would not budge. We were locked in!

We searched every window, most of which were either painted or nailed shut. We were not about to break any windows but were sorely tempted as panic began to rise. Finally, someone came walking by and we yelled to them through the security door window to come open the door because we were stuck inside. The person, for some strange reason (I don't remember if it was a man or woman) looked at us strangely, but then decided to come help us out. Thank God!

Of course, I didn't let that deter me from exploring a couple more times after that until I discovered I was pregnant with my first child and had to stop. That was in the year 1995.

Not long after moving to Cordova, Tennessee (thirty minutes outside of Memphis), in September 2015 to be with my significant other, Paul (also a photographer), I met my current exploring partner, and photographer in his own right, Mark Harbin. He had a passion for shooting models in abandoned spaces in my original steampunk fashion designs and while he was busy shooting the models, the old exploring bug from years before bit me again. Only this time, I was armed with a cell phone and a DSLR.

Before long, we were off exploring abandoned properties from Cordova to Mississippi and Arkansas in between model shoots. I also had to eventually give up fashion design, as my oldest son came to live with us after graduating trade school and moved into my sewing studio—the only space left in the house for him to live. Plus, the desire to photograph and explore has been much stronger than the desire to sew. Also during all of this, I picked up regular paid work as a real estate and food photographer.

Though I have fallen in love with Memphis since I have been living here, as it is rife with opportunities for artists such as myself, it can be equally dangerous. While doing a photoshoot in the long abandoned American Snuff building on the north end of downtown, someone came in and stole a good amount of my photography gear, including a new backpack that had inside it a portable strobe, a flash, and other related items. They also stole my pop-up changing closet. No cameras were taken though, as I had those on my back.

It was strange, as we never saw anyone enter or leave, but on further investigation we were advised that at any given time there could be up to ten people in that

enormous multi-structured compound that even included a department store-sized basement that was not lit at all. One time, I photographed my son Jordan in the tunnel down there, and the whole time, even though I had a flashlight and my son with me, I was shaking with fear until Mark showed up with the model he was shooting on the other side of the building and assisted me with completing the shoot.

And yet, I keep exploring. It's like an addiction—I keep wanting to go back. And that's what fuels me and inspires this book to be written.

1

ABANDONED NORTH MEMPHIS

UP TO SNUFF

The American Snuff Company building is an enormous, abandoned multiplex that was built starting in 1912. It is located on Front Street in Uptown North Memphis. At one point, there were 500 workers in the nine-building complex that manufactured various tobacco brands and products until they moved out of the building in 2012. It has sat unused since.

I was first introduced to this massive structure by my exploring partner, Mark. We collaborated on his photoshoot with a model wearing one of my steampunk fashion designs. Once I finished dressing and styling the model, he began shooting her. Then I went around snapping pictures.

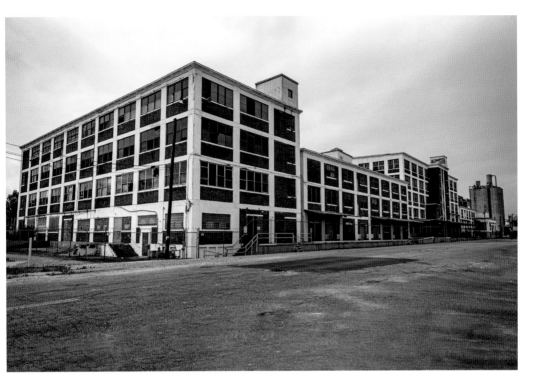

The American Snuff Company building. Located on Front Street in Uptown North Memphis.

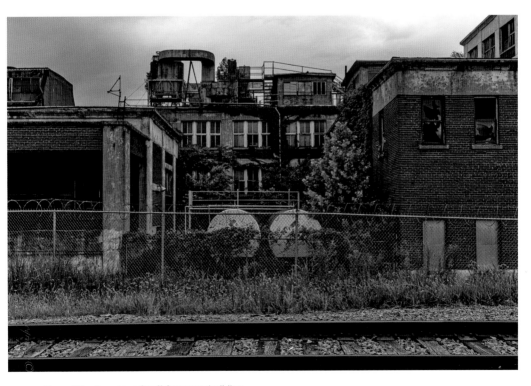

Rear of the American Snuff Company building.

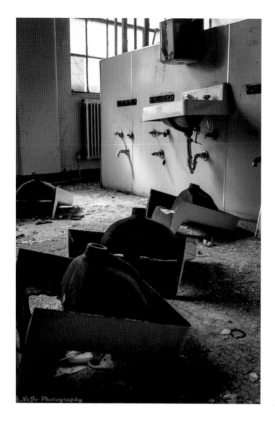

Where the workers used to clean up. This is located just outside of the restroom stall area.

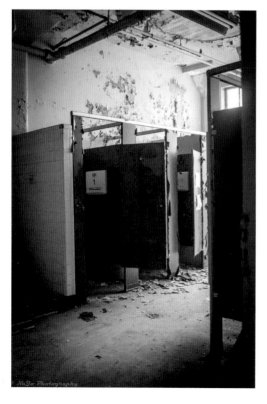

Restroom stalls.

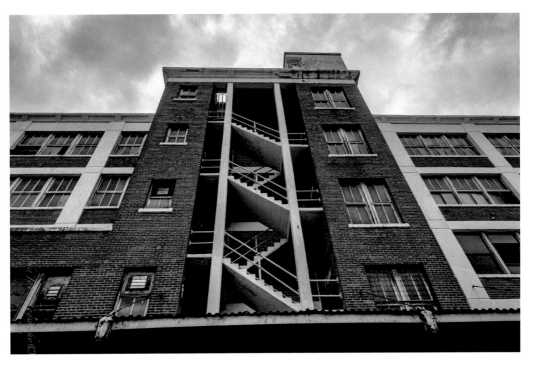

Front staircase of the abandoned American Snuff building.

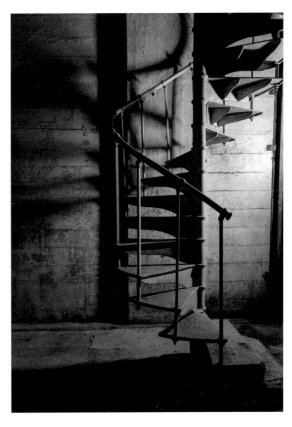

Sapiral steps that lead downward into the
eerie basement. [*Mark Harbin*]

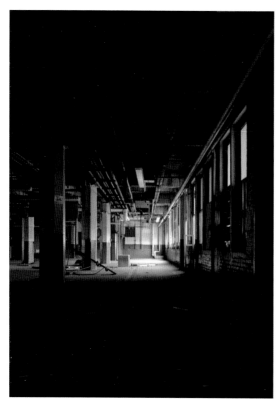

One of the many, many work areas in the massive building. [*Mark Harbin*]

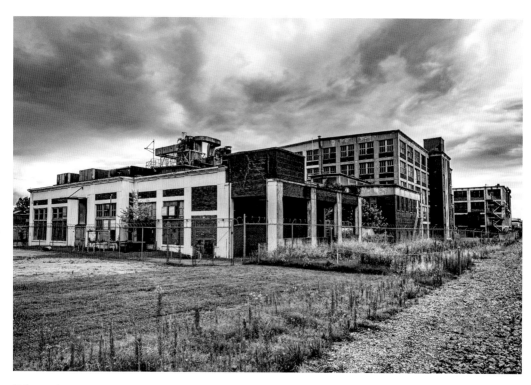

Full rear view.

Rotting stall door.

THE "BRICK CHURCH"

It wasn't long after I moved to Tennessee that I passed by this tall derelict church on Chelsea Avenue in North Memphis. I said to myself, "I gotta get in there."

I did some research and discovered that this now abandoned church is rich with history. It began as the Third Presbyterian Church in 1856 and was completed in 1860. Two years later during the Civil War in the First Battle of Memphis, federal troops took over the church using the top floor as a hospital and the bottom floor as a place to keep their horses. In 1916, the church was renamed Chelsea Avenue Presbyterian. The moniker "Old Brick Church" came from the fact that it was the only brick church in Memphis at the time.

It is so sad that it is now sitting unused and deteriorating. So far, I haven't found any information as to how long it has been abandoned, but there doesn't seem to be any plans to redevelop this property.

We parked on the side of the road a little ways from the church so no one would notice us for a time as we went in to explore further. At the time, the fence was knocked down, and just about anyone could walk in. That made our visit here very concerning, as Chelsea is known as one of the worst neighborhoods in Memphis. But we charged in anyway, hoping for the best.

Inside, on the bottom floor, appeared to be a room that was once used as a classroom. There was a portable chalkboard there along with a couple of oddly placed pews and a chair that looked like it should have been in a pulpit. The next room on the right was a smaller congregation area with an old, but in amazingly okay shape, black upright piano in it and a few more pews. Another room connected to this was filled with old and possibly highly valued *National Geographic* magazines and others.

On the floor, I also found an old bill from a Coca-Cola company dated from the 1970s. So apparently the church was still in use at that time, with a soda machine in it?

On the way upstairs we passed something that resembled a bar, but upon closer inspection, we saw old baby cribs and small pastel-colored chairs. This must have been where the children were kept during church services.

In a space behind us, which was extremely dark, there was a large iron bell. I could only assume this was used on the top of the building when church was actively in session. Now it sits in ruins on the nursery floor.

In the main hallway where the stairs were, there was an area that looked as if it was being remodeled at one point, but then the project was halted for some reason, and now the tall wooden scaffolding sits deteriorating with everything else. There was no railing (or bannister) on the stairs to hold on to on the way up, so we had to be extra careful. The stairs were extra sturdy, thank God, and we made it to the main congregation area immediately to the right.

It was a huge, depressing site to behold. Loads of dark-brown sawdust covered just about the entire floor of the room of former worship. It was covered to the point where we couldn't tell if our next step was a safe one, as the floor was indeed weak in places. The ceiling was of course mostly gone. A couple of ceiling fans still holding on up there had warped blades from many years of hot Memphis summers. There was nothing left of the pulpit but a stage; we quickly discovered upon trying it was unsafe to stand on. Another old upright piano was in the corner, but it was in abysmal shape, unlike the one downstairs. There were a few decrepit wooden pews remaining and an eerie site in the middle of the room; a group of more little child-sized wooden pastel chairs placed, it seemed, purposely around and going into a square hole in the floor. It appeared to be left perhaps by a prior urbexer as some sort of joke or whatever, but it was nonetheless creepy.

Miraculously, no graffiti was sprayed on the walls—one of the rare abandoned structures in North Memphis granted this respect.

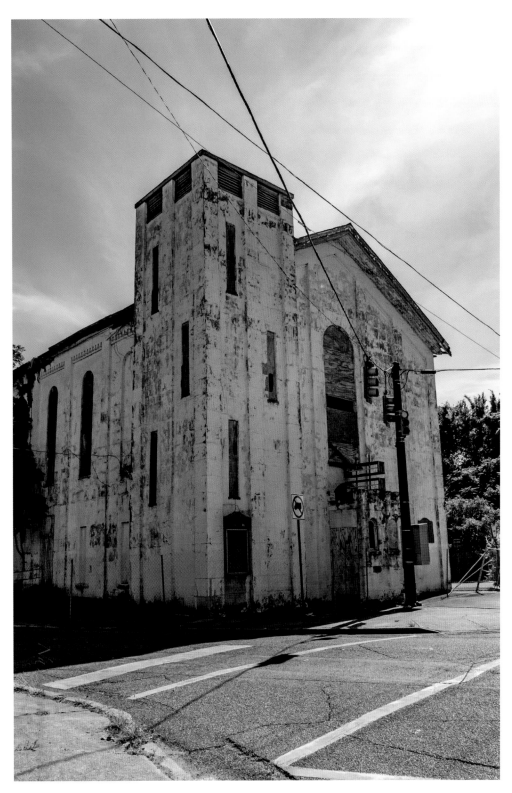

The "Brick Church."

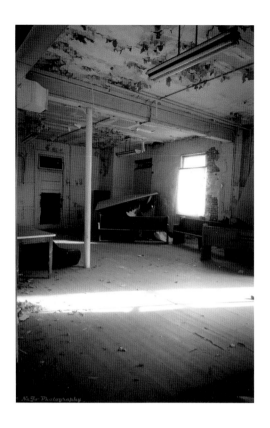

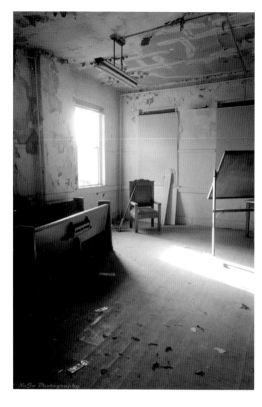

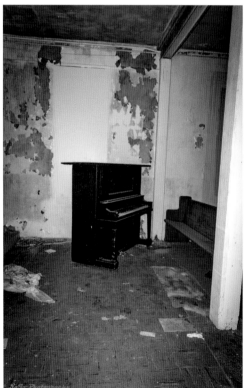

Above left: Sunday school classroom.

Above right: Another view of the Sunday school classroom.

Left: An upright piano in the downstairs sanctuary.

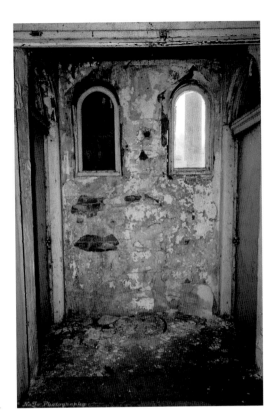

The front entrance.

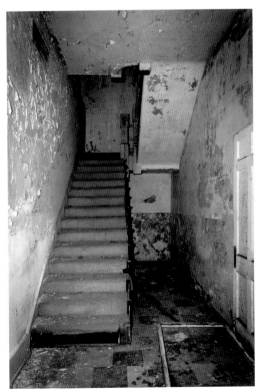

Staircase to the main sanctuary upstairs.

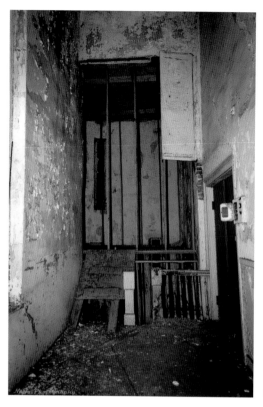

Unfinished renovations ... ?

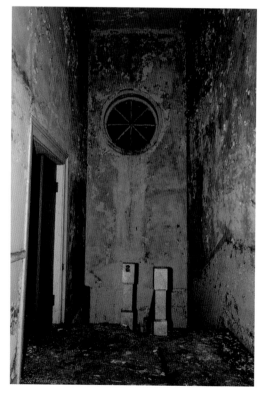

Upstairs hallway. Circular window now covered
with plywood.

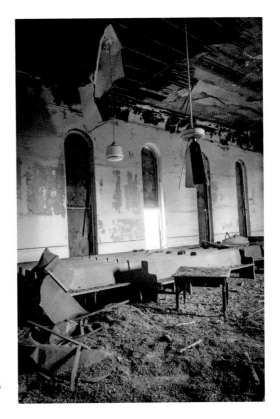

Inside the main sanctuary. Loaded with old pews and sawdust.

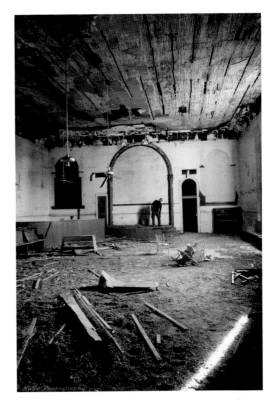

Main sanctuary. My exploring partner, Mark, standing in the pulpit. He must be searching his cargo pocket for a Bible.

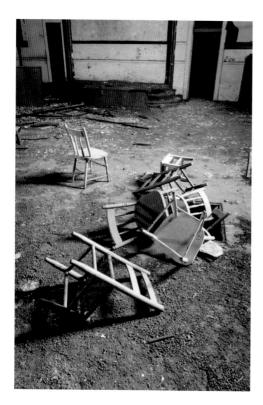

A peculiar sight: a collection of small children's chairs toppled over and leading into a dark hole in the sanctuary floor. Hmmm … perhaps they didn't listen well enough in Sunday school. Very creepy.

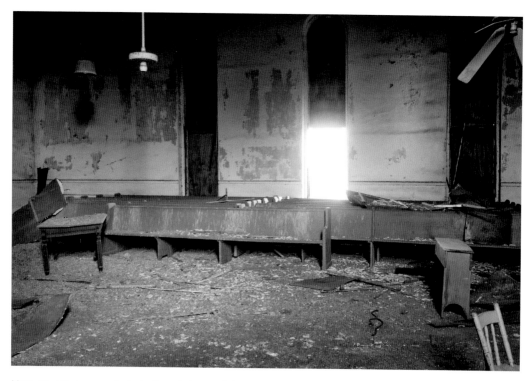

More pews that appear to be in decent structural shape despite the many years of abandonment. An ironic guiding light shining above them.

The Firestone Building

I was in awe of the towering smokestack that remains standing on top of the last industrial building left of the long-abandoned Firestone Tire & Rubber Factory. At one point this factory covered 40 acres of land. Now, not so much.

It was opened in 1936 and at one point employed up to 7,000 workers, but due to the creation of radial tires in the 80s and the fact that Firestone wanted to keep manufacturing the unpopular bias-ply tires, the factory had to shut its doors for good in 1983, devastating the local North Memphis neighborhood and economy.

At one point in the early 2000s, there was a youth golf facility being developed on the property called First Tee, which explains all the hundreds of golf balls and bags still lying around on the site today. However, when they first began to break ground for the planned nine-hole golf course, they found many underground tunnels and "catacombs" that must have been there for at least fifty years or so. This understandably played a huge role in halting this development.

When Mark and I arrived there to explore what was left, there was a portion of the chain-linked fence that was run down onto the ground, perhaps by a large truck or a determined group of prior urbexers. Not sure, but we persevered, walking right over it.

There was no way of entering the Firestone fortress. All "windows" and doors were bricked shut and looked as if they had been that way for a solid thirty-five-plus years. I walked around and took some exterior shots.

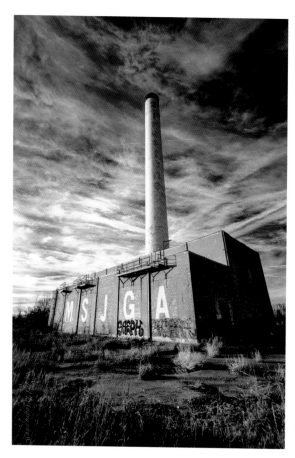

The remaining portion of the old Firestone Tire & Rubber Factory including the smokestack. This photo is my infrared rendition of the ruin.

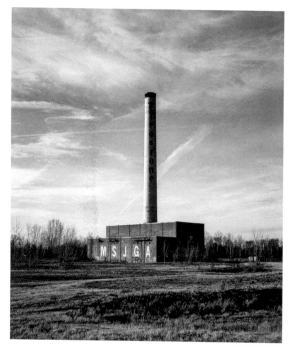

Another photo of the Firestone Factory on black-and-white medium format film.

HIDDEN BEAUTY

A little further up north on Highway 51 away from the Firestone building, we almost missed a giant two-story hidden treasure on our left. Good thing it was winter, or we would never have caught a glimpse of the roof behind the green bushes of summer.

During our first visit here, we parked at the end of the long debris-strewn driveway that led up to the long-abandoned house. As far as abandoned single-family homes I have been in, this was the biggest I had ever explored.

From what I could gather online on the Trulia website about this home, it was built in 1941 and is approximately 3,232 square feet in size. It also included four bedrooms and two bathrooms, nine rooms in total, and is sitting on an allotted 10 acres of land. It had a once beautiful screened-in breakfast nook (or porch) and a massive two-car garage attached.

Years of neglect have taken its toll on this once very lovely place. I couldn't find any history on who lived here before, but did find some 8 x 10 photos of Nazi buildings and other related film photos on the property. I also found some 35mm film negatives lying here and there.

I took one strip of the dirty negatives home, cleaned them off as best I could, and scanned them. What emerged were photos of a Caucasian man in hunting gear and Caucasian women behind a bar, perhaps in a local pub or something.

But upon further investigation during another explore of this home (three in total), I began to find a heap of what appeared to be the belongings of the prior resident(s), books that were about, and written around the time of, the civil rights movement. For example, there was an autobiography of activist Angela Davis in the pile by the winding stairway and other African-American literature. Upon seeing this I was confused about the Nazi paraphernalia and film negatives I found outdoors lying around. Something was very interesting about this property, indeed.

The home looks to be sadly beyond repair now. All the windows are broken out, the floors are buckled, peeling paint is everywhere, and there is loads of water damage—but thankfully, no graffiti on the walls, probably because this place is not easily seen from the road for vandals to get to it. Also, there was a lonely couch in the living room, but no other furniture that we could see.

It would be nice to find out what happened here, but until then, it is on to the next abandoned exploration.

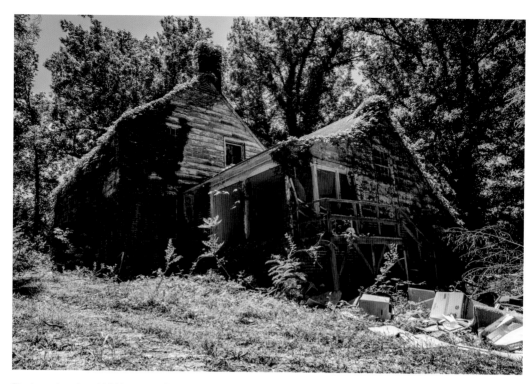

The long-abandoned hidden gem off Highway 51 in north Memphis.

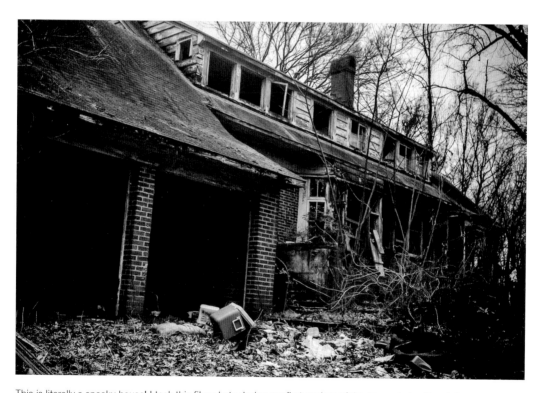

This is literally a spooky house! I took this film photo during my first explore of the home during the winter.

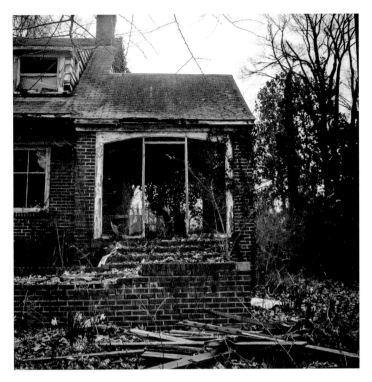

The breakfast nook.

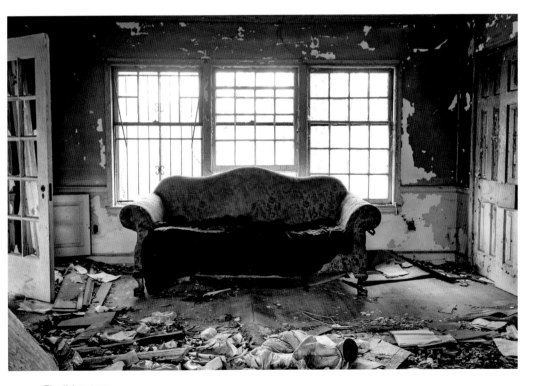

The living room.

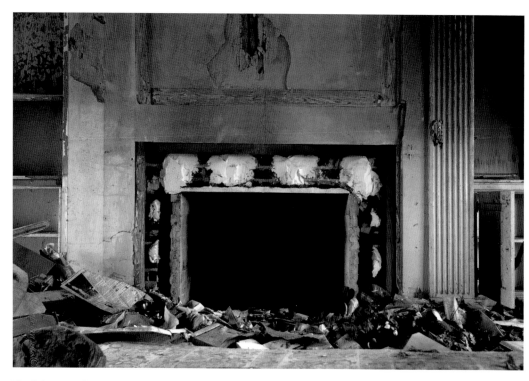

The living room fireplace.

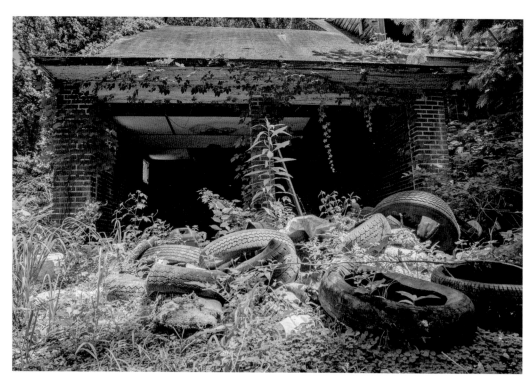

A garage full of tires.

DIE

A brief deviation from North Memphis now to a spot closer to the Shelby Forest area.

I was exploring with my boyfriend, Paul, and exploring partner, Mark, driving around looking for a lone tree to photograph as Paul was wanting a dramatic landscape photo. As we made a left off of Walsh Road, a white dilapidated structure on the left, tucked into the winter woods, snagged my eye. I told Paul to stop the van for a second so we could get a closer look. He slowed down reluctantly, but then continued to drive on, as he was not into the urbex thing at the time.

Mark and I knew we had to return to this small, obviously abandoned home and see what mysteries we would find in it at a later date.

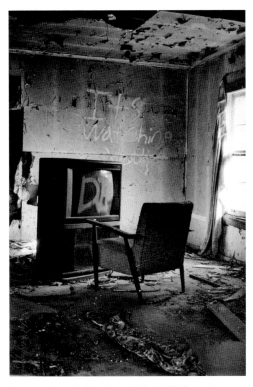

It seems the television is watching YOU for a change.

Another week or so later Mark and I did return to the house, parking the car as far into the brush-covered driveway as possible, but the back end of the car was still visible to the main road. So we had to make this explore quick!

We fought through thorny bushes and stepped over twisted vines to get to the porch. The main door was opened, which kind of creeped us out, because that most likely meant that others had been in there, or could still be there.

What we saw in the living room of the home was enough to make us pause. Spray painted on one wall were the words: "It's watching you!!" On the other wall on our right was written: "No return." In the middle of the messy floor was an old square cushioned chair with an equally older model console television with the word "DIE" spray painted on the screen. This scary site definitely had our skin crawling, but I still could not resist taking a few pics of the scene as we found it before leaving … FAST.

Machete House

This is a long-abandoned gem on James Road in North Memphis. We spotted it while driving on the way home from another explore and decided to check it out. James Road is very busy, so we were somewhat comfortable pulling right into the overgrown driveway in front of the house. Perhaps no one would bug us, thinking we were there to inspect the property or something. If so, they would be partially correct.

I mainly took exterior shots of this two-story home, because upon looking through the front window, I saw that the floor downstairs had collapsed under the weight of tons of trash and debris. Ironically, the upstairs floor seemed to be intact.

As we were finishing up and packing our camera gear to leave, we noticed a rusty machete laying ominously on the ground. Mark and I were creeped out because we didn't notice it laying there upon arrival, as it was laying on the gravel of the driveway. I got a few shots of it as well, and left promptly.

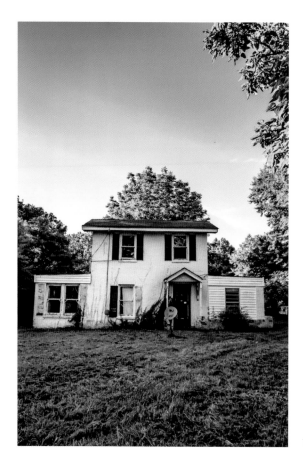

The "Machete" House.

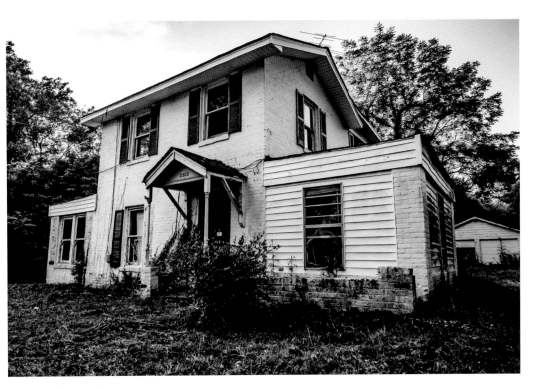

A closer look.

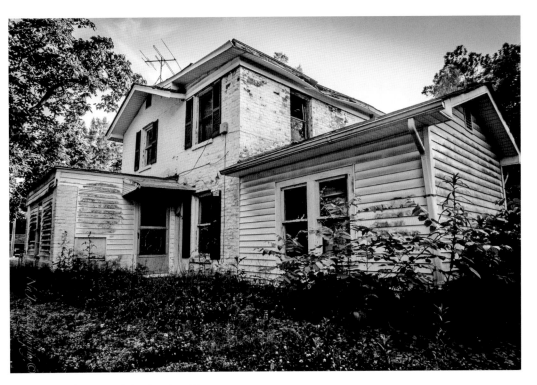

View of the rear of the abandoned home.

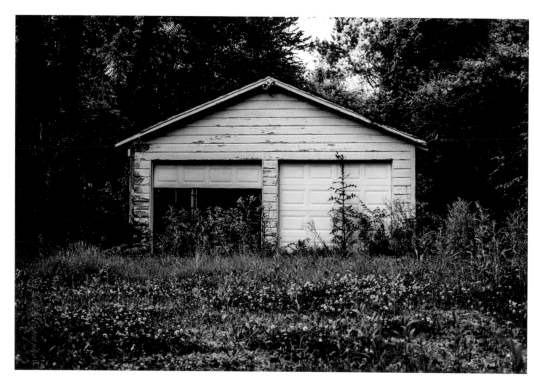

A winking garage.

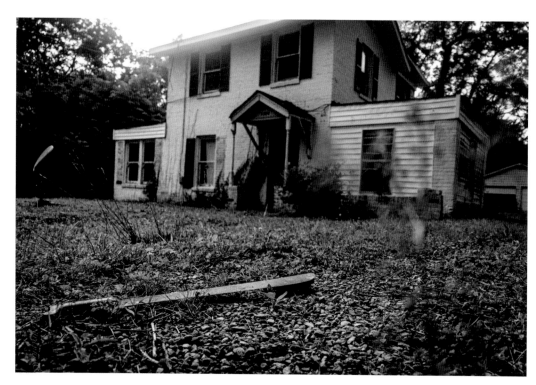

The MACHETE!

A Mangled Mess

Formerly Worley Brothers Scrap and Iron Metal, this tremendous, mangled mess of what is left sits off Chelsea Avenue. It is not visible nor accessible from the street, so we had to go through a nearby housing project and knee-high grass to get over to the property.

Mark guided me here as he had done some photoshoots here in the past when the building was more intact; since then, a large fire had apparently destroyed most of the building, leaving it in its current gnarled condition.

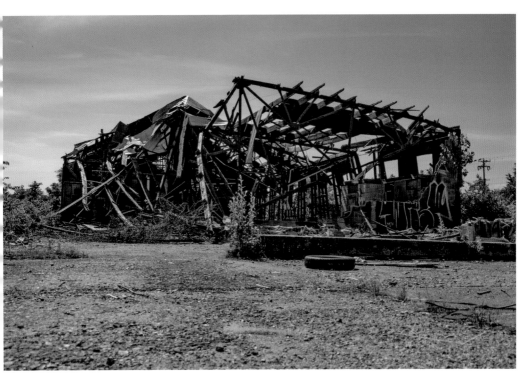

What is left of Worley Brothers Scrap and Iron Metal after a fire. There are a few office spaces left in the back, but they are far from usable.

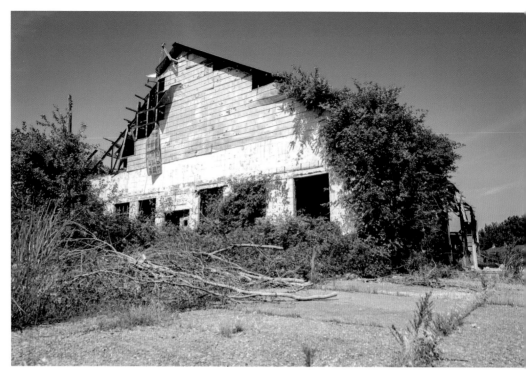

Section where the old offices are still somewhat standing.

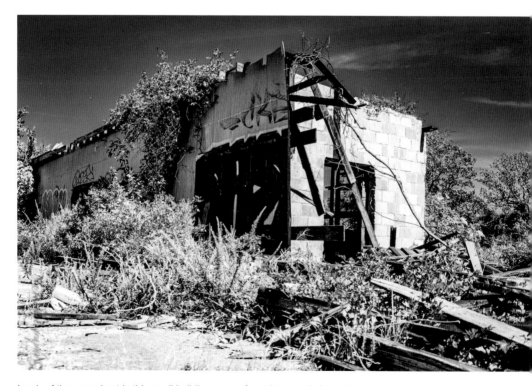

Loads of tires were kept in this small building across from the mangled warehouse.

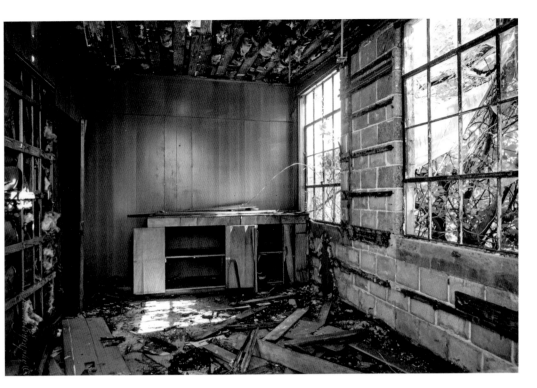

One of the offices.

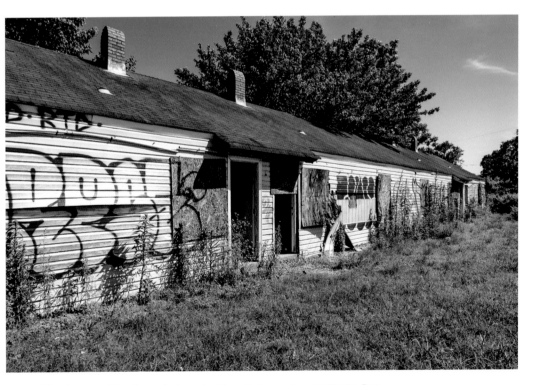

The abandoned housing projects we had to walk through to get to Worley Bros.

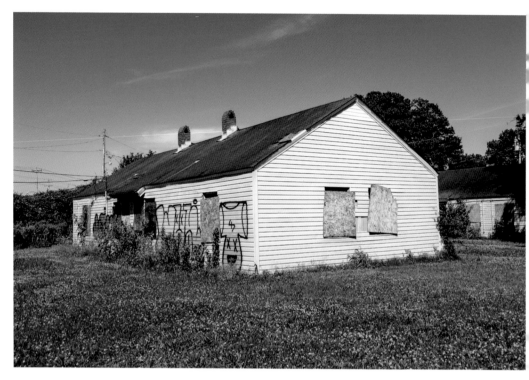

Another abandoned project building.

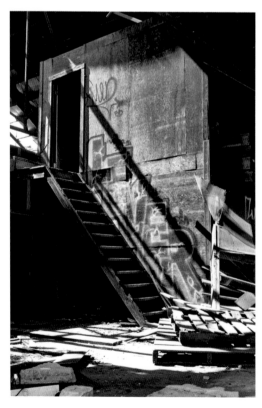

Stairway to other offices in the warehouse that survived.

2

ABANDONED SOUTH MEMPHIS

EVANGELICAL FAITH CHURCH OF GOD IN CHRIST

This isn't as much a story of an abandoned building, but a church that was unfortu-
nately left to decay and broken into by vandals and the homeless while caught in legal
limbo. According to a post on the Evangelical Faith Church COGIC's Facebook page,
on December 10, 2012, a bank based in Nashville, Tennessee, "illegally" boarded up
the church, effectively locking the congregation out shortly before Christmas holidays.
The pastor, Dudley Lewellen, stated that this lockout was the result of a mistake
on the bank's behalf and he, along with the displaced congregation, are seeking
reparations for this. The bank, of course, is making this difficult for them to rebuild.

The church was in operation for twelve years prior to the forced closing. I first
spotted this church in summer of 2017 when I was working at a photography studio
nearby. As with any large derelict structure, this piqued my interest and I wanted to
learn more about it. I asked a fellow co-worker, George Jones, to join me in exploring
the church. As he had a similar interest in abandoned buildings, he said yes.

On our lunch we drove down to the church. At that time, I did not know the name
of it, or anything else about it. We walked in on the side where what seemed to be
classrooms were lined up. The rooms suffered terrible water damage from just five
years of sitting unused. However, a library full of books that was in the middle of
the breezeway was in decent condition. We then turned our attention to the main
congregation areas.

There appeared to be two sanctuaries. The smaller one was boarded up to the
point that there was no visible light coming into the large room. We could not see
our hands in front of our faces in there and all we had was our cell phones, so we

quickly exited that space. The second sanctuary was enormous and beautifully lit by the natural light coming in through the upper halves of the tall boarded-up windows. The alter was still decorated with Christmas wreaths from December 2012. This sanctuary was in remarkably decent shape, except for the pews that were all pushed over with the bottoms removed. There was no graffiti on the walls both outside and inside of the church. Amazing!

Standing inside of this area of worship, I couldn't help but be in awe of how well preserved this part of the church was. It felt as if the rest of the buildings surrounding the sanctuary suddenly collapsed and this room was all that was left. Of course, there was a small amount of trash on the slightly molded navy-blue rug, where it seemed a few vagrants may have eaten, but there was no sign of water damage (unlike in the classrooms), the light fixtures were still hanging from the ceiling untouched, and all the glass was still intact. There was a balcony as well, but we had to return to work.

A few weeks later, I was joined by Mark, as I wanted to return to the abandoned church and do more exploring where George and I left off. He too was amazed by the sanctuary, but the covered breezeway that was okay when I had last seen it had partially collapsed, so there was no longer any access to the library.

This time we went up to the balcony in the sanctuary. Just like downstairs, the pews were turned down, but there were old molded clothes strewn everywhere, as if a group of people lived there a few years before but suddenly left, leaving all of their clothes and shoes behind. It was interesting, but sad at the same time.

According to the Evangelical Faith Church of God in Christ's Facebook page, as of July 19, 2018, after five years of legal battles, the bank finally agreed to a settlement with the congregation and they are looking to rebuild. I do hope they have gotten their wish as very recently (2019) I passed by the church again and it looks like work of some sort is being done there.

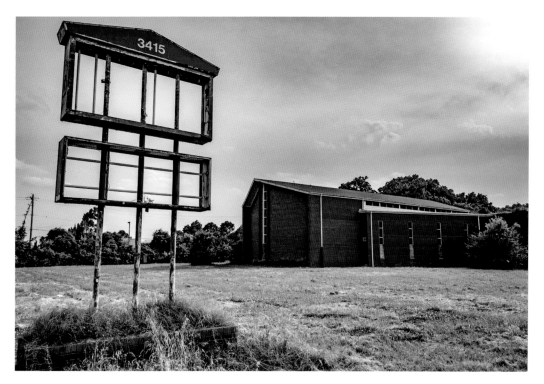

An empty sign stands in front of the abandoned Evangelical Faith Church of God in Christ.

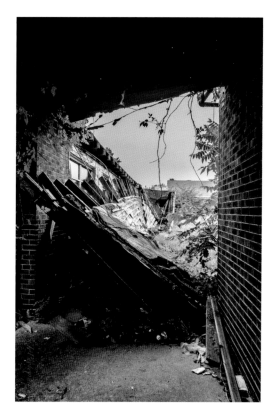

Collapsed breezeway where the library and classrooms are located.

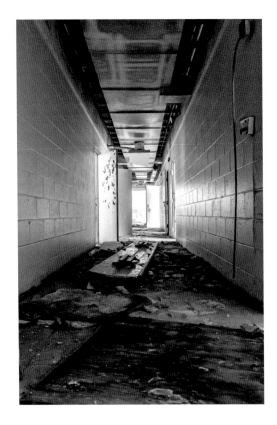

Long hallway from the breezeway area to the back of the church.

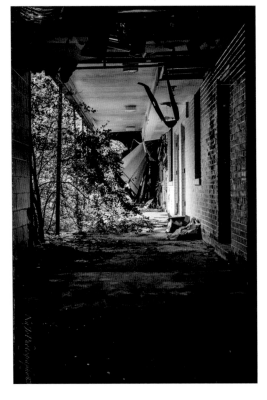

Another look at the collapsed breezeway from a different angle.

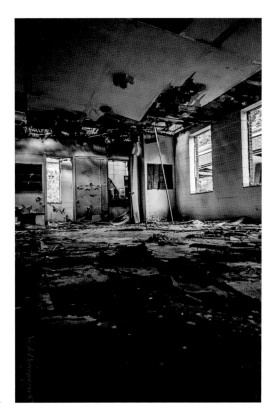

One of the dilapidated classrooms.

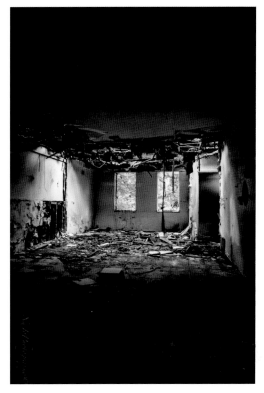

Another classroom ravaged by time and elements.

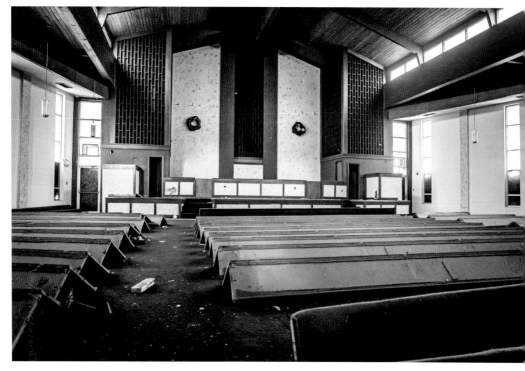

The awesome main sanctuary. There was no graffiti despite the ease of access to this building. Amazing!

MARKET PLACE BAPTIST CHURCH

This sad-looking abandoned church sits on Wicks Avenue. Its main entrance doors sit wide open and apparently have been stuck that way for many years. It is a simple square brick building with purple stairs leading to it. A white wooden building connected to the church in the back is opened for errant entry as well, with many broken windows. As Paul, Mark, and I sat in the parking lot for a few minutes before bravely exploring this place, I witnessed a couple of suspicious-looking guys coming out of the white building in the back. Perhaps they thought we were coming to inspect or something, as the three of us make a diverse-looking group, plus we were in a black late-modeled van. The men looked to be untrusting locals, so that made this explore a bit more nerve-wracking than usual.

Mark and I went up the purple-painted stairs and through the opened entranceway first. The first bit of debris to greet us was a large bedroom dresser. It was laying on the floor across the hallway, somewhat blocking our way into the sanctuary.

The pictures describe this eerie scene so much better than I ever can, but will give this a shot. Eerie is not quite a strong enough word to describe this. The sanctuary

looked as if church could still be taking place on Sundays if the members are vandals, graffiti artists, and drug addicts who wouldn't seem to mind the molded, loud purple rugs covered with old rotten clothes, a couple of sunken decaying pews, and a few shattered stain glass windows.

The steps to the altar and choir were also blanketed in the moldy purple rug. Choir pews upon which glorious (I assume) singers once sat are now broken down almost to splinters—most likely the handy work of determined hoodlums combined with rainwater leaking through the ceiling over time.

Miraculously, left untouched in the baptism area is a scenic picture of mountains and a river. It appears to be the sort of picture that you find in second-hand shops nowadays that light up and may have even played sounds of ocean water flowing. But not now. The only glow emitting from that image now is a creepy one. I couldn't take my eyes off it very long for some reason.

Then, Mark loudly whispered over to me that he saw someone walking around upstairs. I hurriedly snapped a few more photos on the way out while asking him if he was sure of what he saw. He emphatically replied, "YES!" I of course took his word for it and we scrammed out of there.

As soon as I got back into our van, I realized I had inadvertently picked up a few souvenirs from the church: hives. Little bumps started raising up on my skin; first on the back of my right hand, then on my left wrist, and they were extremely itchy. I told Mark, who was in the back seat and he didn't believe me (or perhaps he didn't want to), until a couple of them popped up on his hand, too. Then Paul saw some on himself as well. He did enter the church briefly after us.

"I'm NEVER going in that building AGAIN!" I exclaimed as we itched and scratched our way to the next explore. Even as I am typing this, I am beginning to feel itchy all over again.

I searched the internet high and low for any history on this Market Place Baptist Church and could find little to nothing. Only confirmation of the address. It's sad, as I am sure this place has an interesting past, but seemingly no future but to continue decaying.

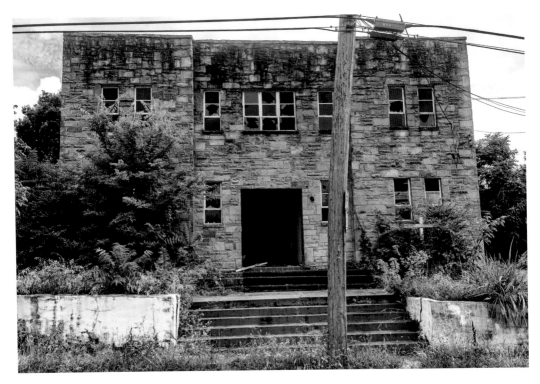

The Marketplace Baptist Church.

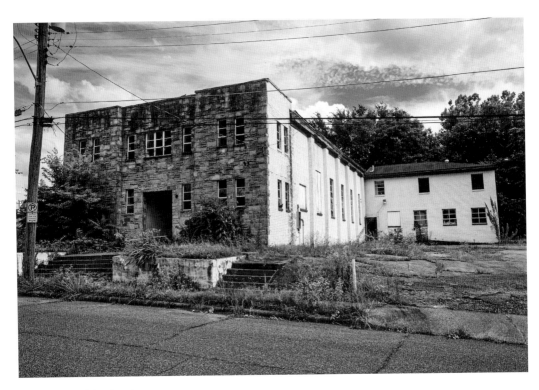

Full side view of the church.

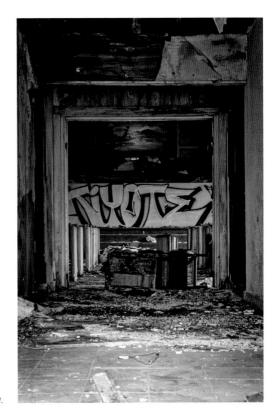

On our way into the sanctuary.

Greeted by a slightly charred dresser.

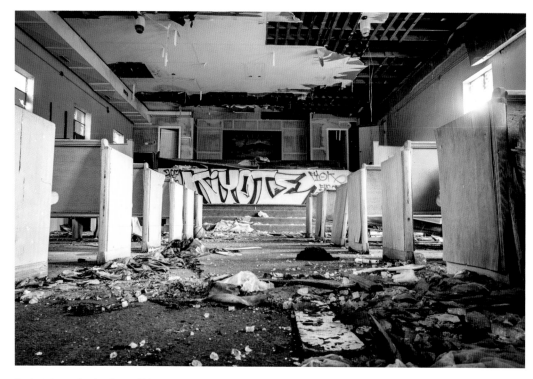

Perfect denomination for graffiti artists here—the sanctuary.

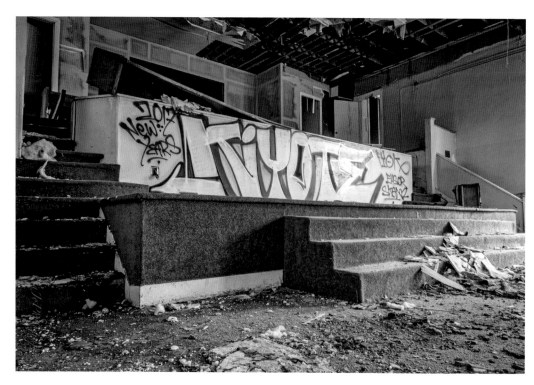

The purple pulpit.

Broken stained-glass window.

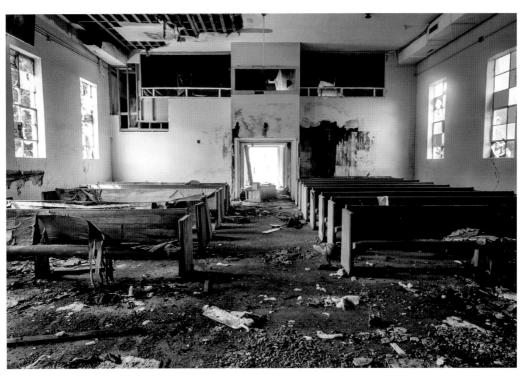

View from the pulpit.

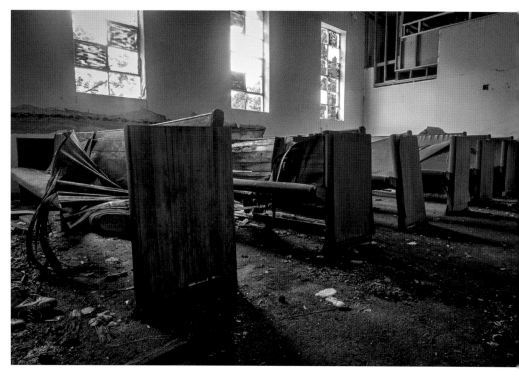

A closer look at the pews.

No Longer From the Grille

Along East Street we spotted a long-abandoned fast-food joint. It was very interesting, as it had no name left on it whatsoever, and it was very well decked out with burglar bars. There was no way of getting into it; however, there was a drive-through menu still sitting on the side as if waiting to take an order. Of course, it was a bit vandalized, but we could still see the menu pretty well. This place served everything from old-fashioned burgers from the grille menu, to pastrami sandwiches from the deli menu, and chef salads from the garden menu. Some of these were unusual menu items for the current condition of the rough South Memphis neighborhood it sits in. That was also why this place intrigued me; but alas, I could find no more information on this one, either. We would've asked a local that was passing through at the time, but he was carrying a pipe and walking towards our van with it. Because he didn't seem to be in the mood to chat, we promptly split!

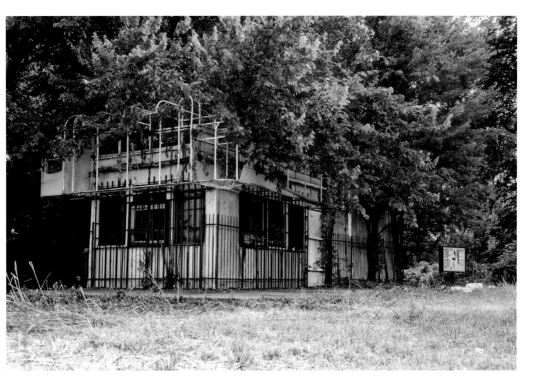

Sorry, nothing on the grille today. An abandoned eatery.

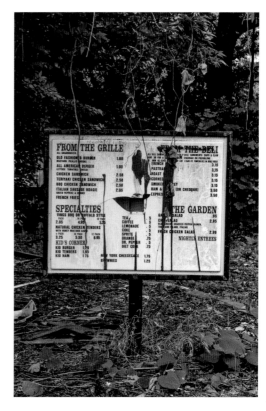

A very diverse menu.

Armco Steel Building

Barely visible off Florida Street in South Memphis is a humongous, hollowed-out, industrial steel structure with a small blue label at the front of it that reads: "Armco Pioneer Building." This structure is the size of a moderate airport hangar with many different departments in it, which we explored in depth, despite the fact that this began to trigger my megalophobia something awful.

I was first introduced to this property by Mark, my regular exploring partner, back in 2015-16 before I became a photographer myself. I actually made steampunk gowns that he loved to photograph on lovely local models. We were a fashion team of sorts at the time. Me, the designer; Mark, the photographer; and at the time, a young aspiring model by the name of Kalissa, along with her mom, Amanda.

This old industrial spot was perfect as a steampunk backdrop. Old, rusted machinery was in the basement, along with a dank dark area nearby that had skeletons of small animals in it—and snakeskins! We used the skull of one of the skeletons in a photo where the model, Kalissa, held it delicately in her hands. It was beautifully spooky.

Here we were in 2019 returning to this spot not for a photoshoot, but to do some exploring. Last time we came, we didn't see any evidence of someone living there, but this time there were nice Polo boots with a white t-shirt and khakis on a clean spot of the mostly soiled and debris-ridden concrete floor, surrounded by old, discarded liquor bottles. This seemed to be his (it was men's clothing, so I assumed it was a man) little bit of paradise surrounded by decaying chaos. All that was needed was a couch and television to complete his cozy corner of the enormous living space.

The multi-stalled bathroom around the corner from the giant hanger-like work area was such a destroyed mess that we could not walk inside of it, but you didn't have to enter it to find something interesting. Stuck inside of a crease in the doorframe was a newspaper, a small tube of toothpaste, and a dusty toothbrush! Yes, this was definitely someone's humble abode and we were obviously intruding. We took a few more shots of the building then left without a glimpse of its inhabitant.

While digging for information on this property, I did find that Armco was once a giant steel production company founded in 1900. There is no mention of this being one of their locations in Memphis, Tennessee, but there were other Armco steel mills located in Ohio, Missouri, and Kentucky. During 1982 through 1983, Armco lost over $970 million and had to close many of their mills located throughout the United States. This may have been one of them, but I could not find any information to confirm this.

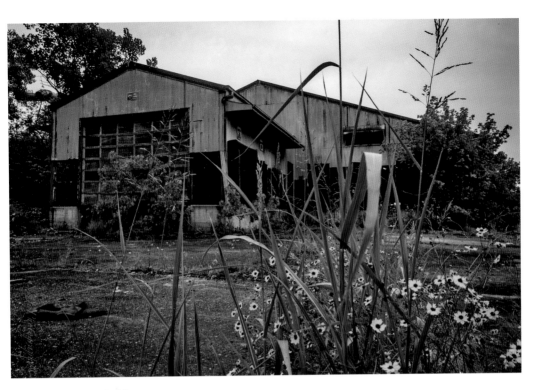

Armco Steel Building.

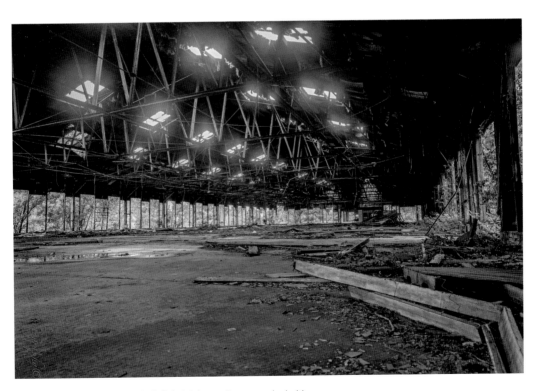

MASSIVE work area! It definitely triggered my megalophobia.

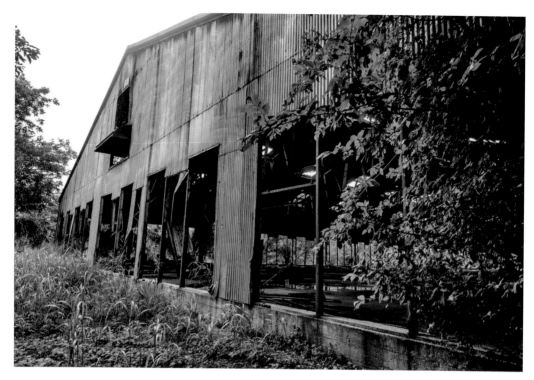

Rear of building.

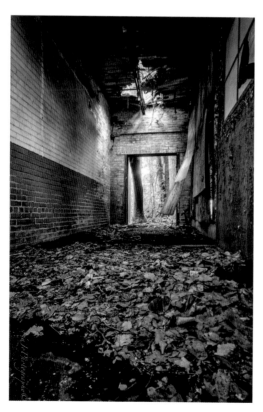

Hallway where workers used to clock in and out.

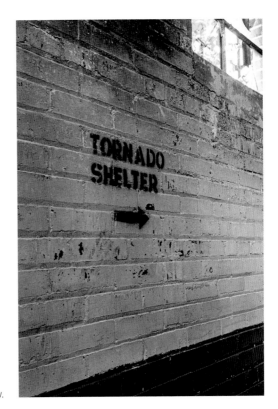

Nice to know.

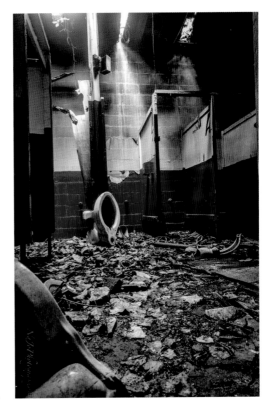

What's left of the restroom.

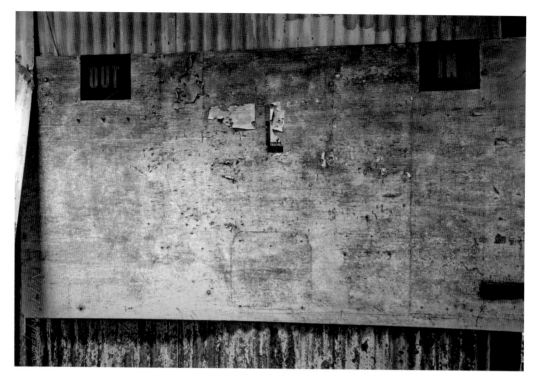

Message board. Also clock in and out station.

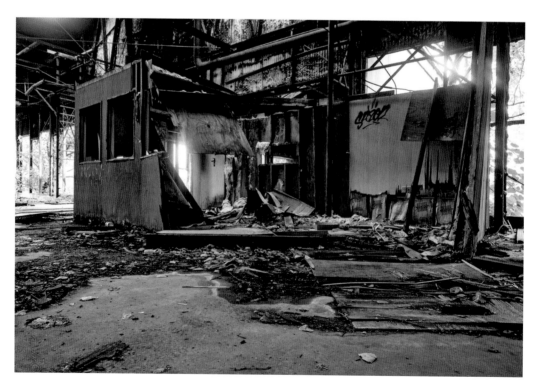

The office.

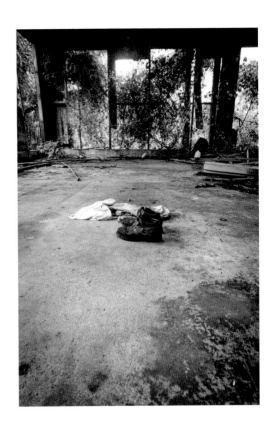

A resident's belongings.

More evidence of a squatting situation crammed
in the doorframe of the restroom entrance.

St. Thomas Catholic Church

Another incredible find, while searching for a spot to do a photoshoot, was this historic ruin: St. Thomas Catholic Church. Again, this was a place that Mark led me to, as we were exploring other derelict properties along East Trigg Avenue and surrounding places in South Memphis.

I was in awe of this incredible brick structure, still standing despite the fact that there was a long crack going down the face of the church. Perhaps this resulted from the collapsed ceiling, but it is still standing despite the damage and neglect over time.

St. Thomas Catholic Church was built around 1925. Under the leadership of African-American Archbishop James Patterson Lyke, this church was active in the 1960s civil rights movement. As a result, a part of Trigg Avenue was re-named after him.

The church has changed hands and denominations many times over the years until a fire destroyed most of the structure, and it had sat largely neglected until 2013-2014, when twenty-eight of its stained-glass windows were carefully removed and placed in storage for display and sale.

I desperately wanted to get into the church, but was advised not to, as the owner (who, last we checked, resides in Nashville) said it wasn't safe. Not only because the structure was highly compromised and could collapse at any time, but mainly because of the pigeons who have claimed it as their home for years, with their poisonous droppings everywhere throughout the former sanctuary floor. They were flying in and out constantly, so I didn't feel it was worth the risk of contracting histo-plasmosis and possibly dying. So, from here, we moved on to the next adventure, but not before snapping a few pictures of this still-beautiful ruin.

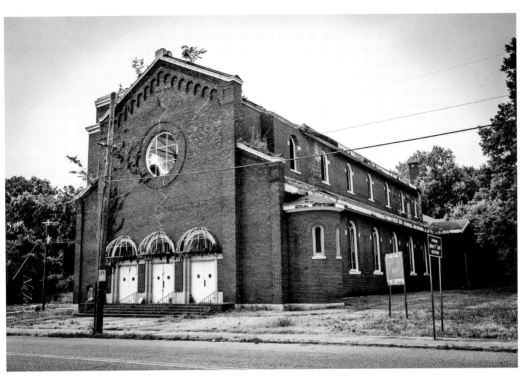

St. Thomas Catholic Church.

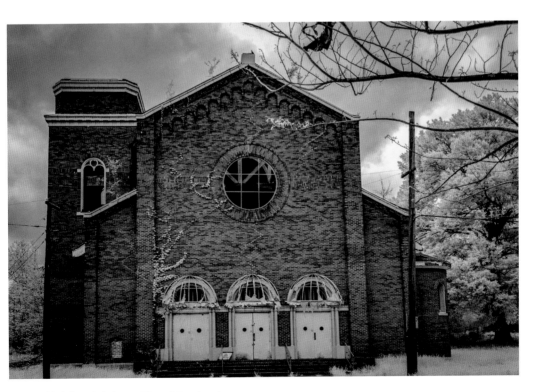

My infrared photo rendition of the church.

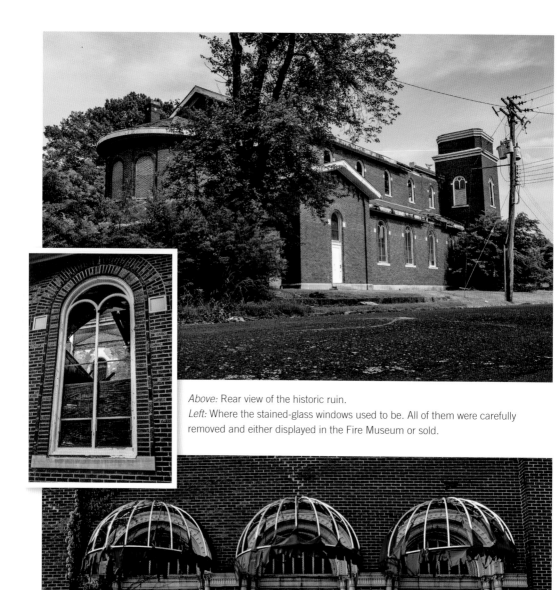

Above: Rear view of the historic ruin.
Left: Where the stained-glass windows used to be. All of them were carefully removed and either displayed in the Fire Museum or sold.

The entrance doors.

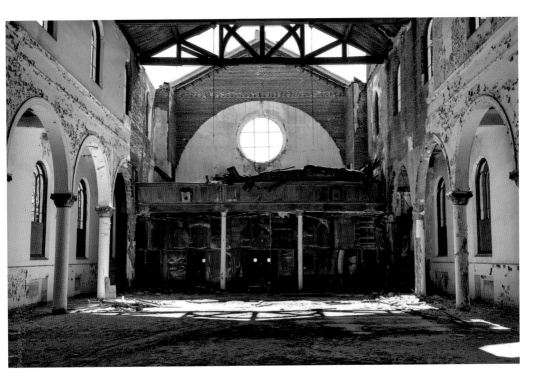

St. Thomas Catholic Church interior.

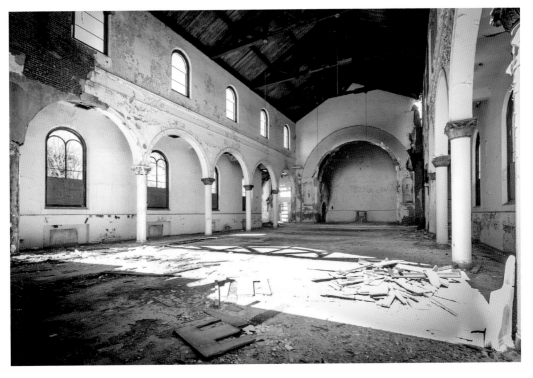

Another view of St. Thomas Catholic Church interior.

THE ABANDONED BIRTHPLACE OF ARETHA FRANKLIN

It is well documented that the birth home of the Queen of Soul is located on 406 Lucy Avenue here in Memphis, Tennessee. Like most of us, I grew up listening to Aretha Franklin's soul-stirring music, and also like most of us, I was devastated when she passed away on August 16, 2018.

Aretha Louise Franklin was born in this home March 25, 1942, to Bishop C. L. Franklin and Barbara Siggers Franklin. The family moved away from Memphis when she was two years old.

I was sitting at my computer watching YouTube while editing some photos from a recent shoot when I received notification of Aretha's death. I thought to myself, "Oh no, another great one gone." I began watching all the news coverage concerning her passing that I could. One of the local stations had a reporter live at Aretha's birth home. That was the first time I had ever seen the home. I was saddened by the apparent rundown condition for the birth home of a true music industry queen.

I was intrigued. I looked up the address online and rushed down there to pay my respects and maybe take some photos before the area around her old home became too crowded with fans, press, and spectators to drive through. I jumped in my car, bumping "Freeway of Love" (my favorite song of hers) on repeat with tears in my eyes as great memories from when that song first came out rushed through my head.

When I arrived on Lucy Avenue, there was a long line of cars ahead of me, almost like a funeral procession already. Aretha's music was being played loudly everywhere, especially from the front yards of the residents who lived directly across the street from the historic home.

You would think that the birthplace of the Queen of Soul would be beautifully preserved and treated as a tourist attraction much like the birth home of the King of Rock and Roll in Tupelo, Mississippi (I know this, as I have visited Elvis's childhood home). Well, it wasn't. Aretha's birth home sits abandoned, with wooden boards where glass windows should be.

If we wanted to tour the inside of the special property, we could not, as the door was closed and locked. Rumor has it that the original bathtub is still in there. What especially bothered me was the condition of the rear of the home. It seemed as if half of it was cut off and taken away, leaving a back wall covered with more wooden boards. I could be wrong about it being cut in half, but that is how it appears.

On top of feeling mournful over the death of a music legend, I also began to feel a bit of outrage over the stark and very obvious difference between how well Elvis's home has been maintained versus Aretha's home, left to basically rot where it stands. It doesn't seem right.

An article I read at the time in RoadsideAmerica.com, titled "Abandoned Birthplace of Aretha Franklin," perhaps explains this obvious partiality best: " … unlike Tupelo, Memphis doesn't *need* Aretha's birthplace; it has plenty of other attractions already." Plus, the neighborhood surrounding the Queen's birth home is a bit rough, but so is the area around Graceland—just saying.

Hopefully, the city of Memphis will reconsider turning Aretha's home into some sort of museum for the many visitors who do come through to pay homage to her. Even though she spent the majority of her life in Detroit, we cannot ever forget where her incredible life and legacy first began.

Love you, Queen!

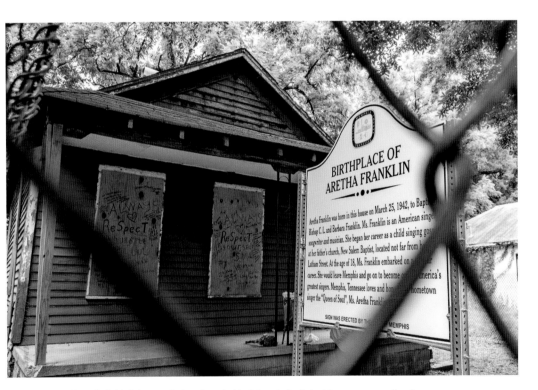

Aretha Franklin's birth home. A view from behind the chain-linked fence surrounding it.

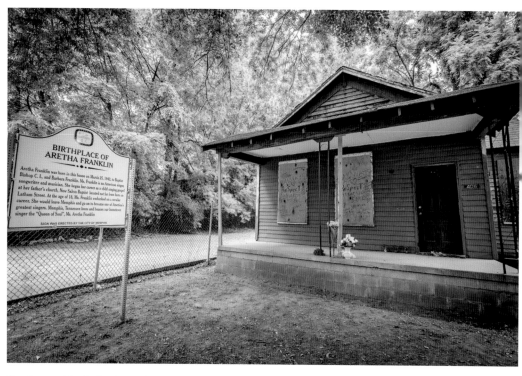

The Queen of Soul's first home. Shame we could not walk through it.

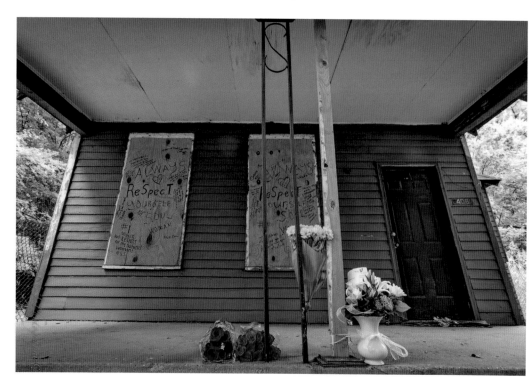

Fans came to pay last respects to the Queen of "Respect."

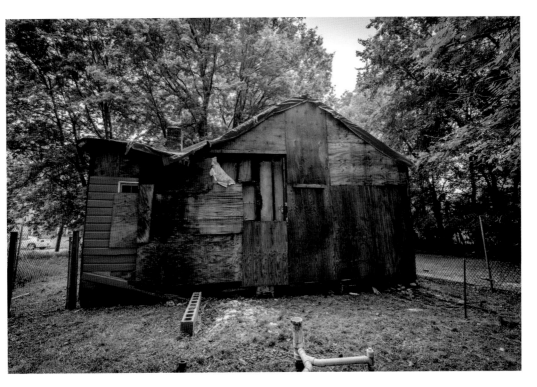

The dilapidated rear of the home.

I pulled back one of the boards to get a sneak peak of the inside, hoping to see the rumored remaining bathtub in there, but alas, there was nothing left but bricks and asbestos.

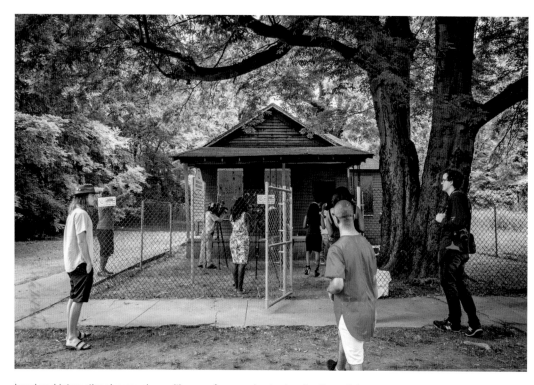

Local and international press along with some fans coming to view the Queen's home.

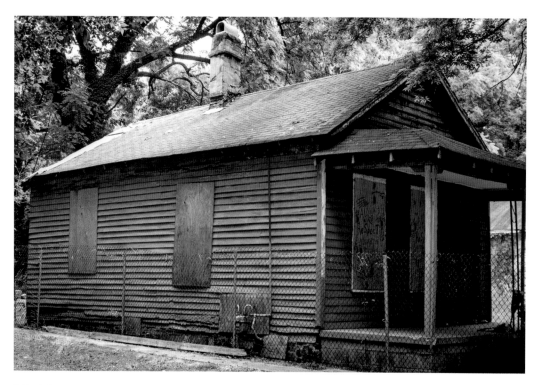

A final view.

YOUNG BUILDERS OF AMERICA BUILDING

Just off Lamar Avenue and sitting on Old Getwell Road is a giant relic of the past that we almost missed. Mark and I were driving around searching for more interesting abandoned properties when this beauty entered my peripheral vision on the left. I asked him to turn back around so we could get a closer look.

I am relatively new to Memphis, Tennessee, having lived here for just four years, so of course I knew nothing about this large abandoned structure that resembles an old school or hospital. I asked Mark, who has resided in Memphis all his life, if he knew anything about this building. He did not. Here the mystery begins.

A sizable wooden gazebo sat on the large, well-manicured grounds in front of the two-storied main building that still had a ragged American flag flying high on a pole before it. We could not go inside because as we got closer to the building there were numerous "NO TRESPASSING" signs posted on the property. The signs appeared to be relatively new ones, so we didn't want any trouble.

I did some digging into the Shelby County Assessor site and found this "mystery" building has been sold three times. The first time was in May of 1977 by the City of Memphis to Shelby County. According to the deed, it looks to have once been a part of a place called Oakville Sanatorium, perhaps built as early as 1912 for patients suffering from tuberculosis (or TB). The name was changed at some point to Oakville Memorial Hospital. The second sale of the property occurred July 2013 to a private buyer. The last sale on record was in May of 2014 to the Young Builders of America Inc.

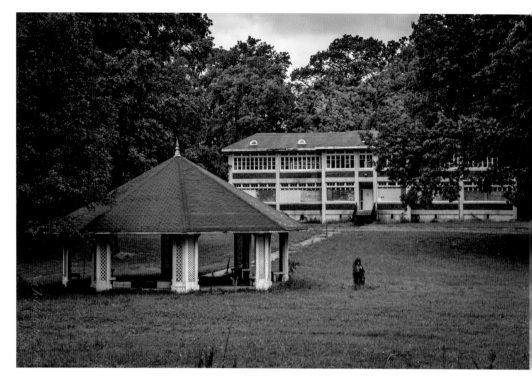

Can't believe we almost missed this one! The Youth Builders of America building (formerly Oakville Sanitorium) along with its large gazebo.

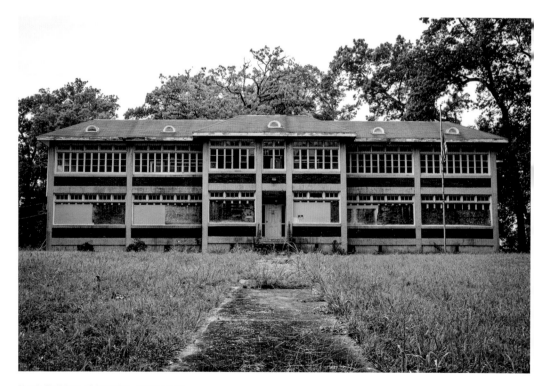

Youth Builders of America. Abandoned.

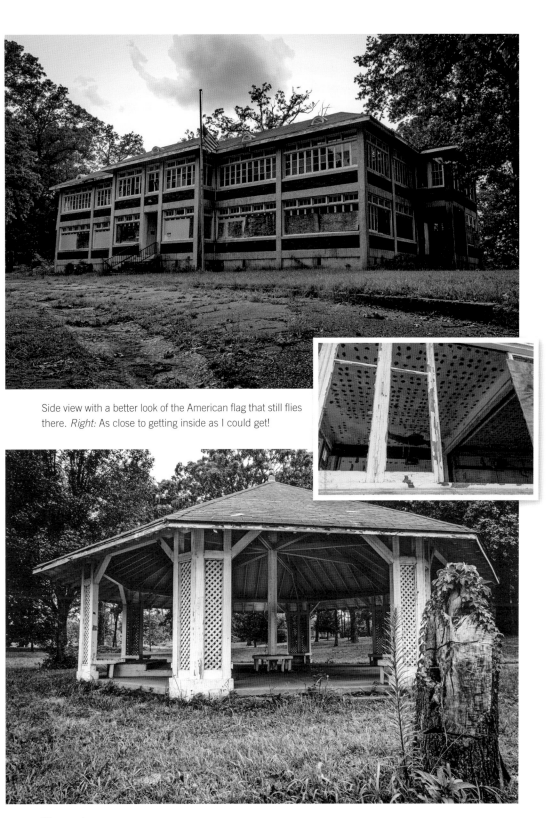

Side view with a better look of the American flag that still flies there. *Right:* As close to getting inside as I could get!

The gazebo.

ENVY NIGHT CLUB

Also located on Lamar Avenue, Envy Night Club was once one of the biggest nighttime hot spots in Memphis. However, I don't see much information about this club past the year 2012 on their Facebook page. No more late-night fun to be had here, unfortunately, as today it sits abandoned.

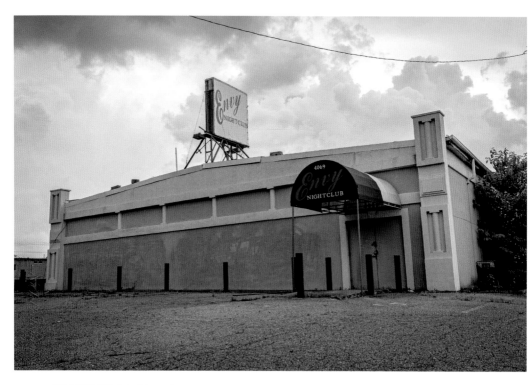

Envy Night Club on Lamar Avenue.

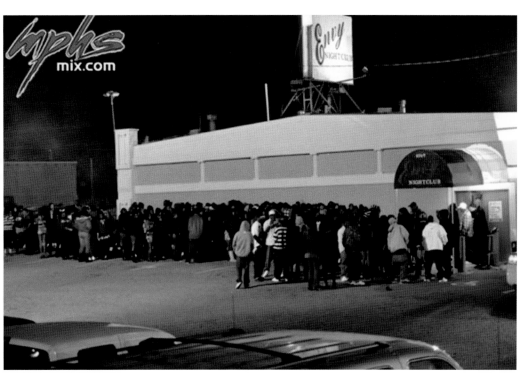

Once one of the biggest, hottest night spots in Memphis, Club Envy now sits abandoned. [*Club Envy's Facebook Page*]

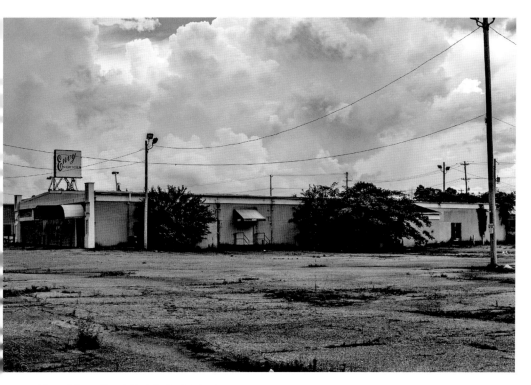

View of the entire night club, front to back.

Spanish Villa on McLemore Avenue

Honestly, there is not much to say about this abandoned stucco beauty except that it sticks out like a beautifully designed sore thumb in this area of South Memphis. I wish I could have seen it back when it was new.

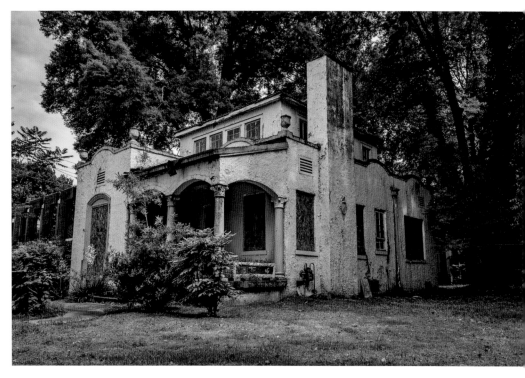

An abandoned Spanish villa in the midst of South Memphis.

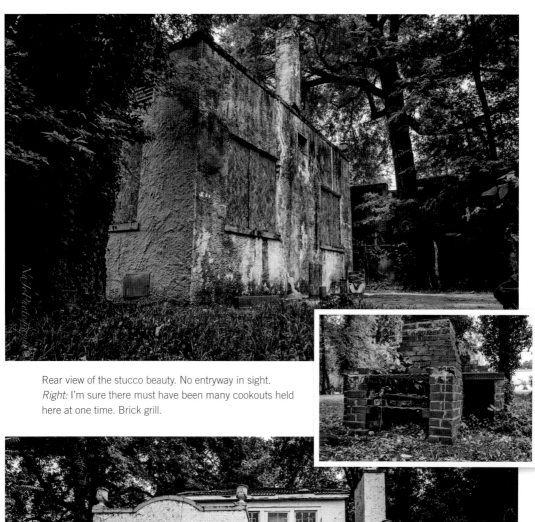

Rear view of the stucco beauty. No entryway in sight.
Right: I'm sure there must have been many cookouts held here at one time. Brick grill.

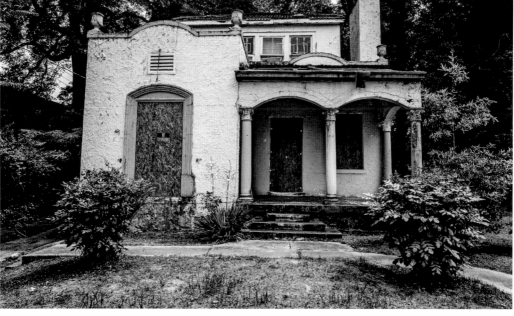

Front view in black and white.

Trigg Avenue Area

These are some abandoned homes that I found particularly interesting while out exploring on Trigg Avenue and surrounding South Memphis streets.

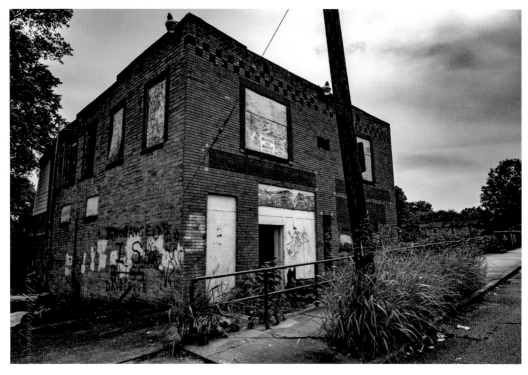

One of many abandoned properties we found along Trigg Avenue. It may have been a grocery store at one point, or a rooming house. Would you rent a room here?

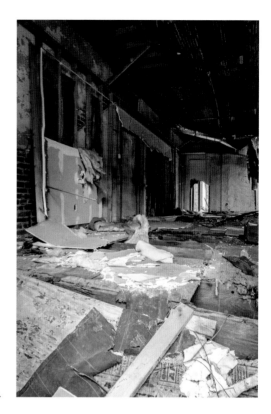

The destroyed interior of the mystery building.

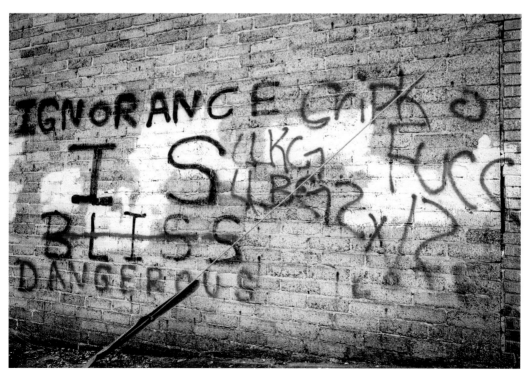

Ignorance is bliss. True.

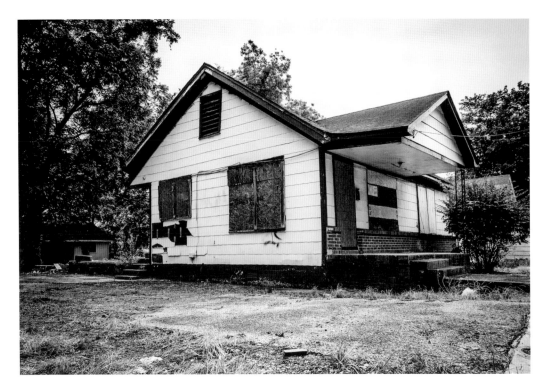

Okay in the front.

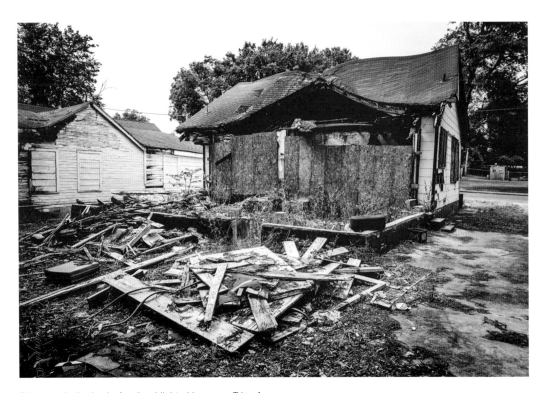

Blown out in the back. Another blighted home on Trigg Avenue.

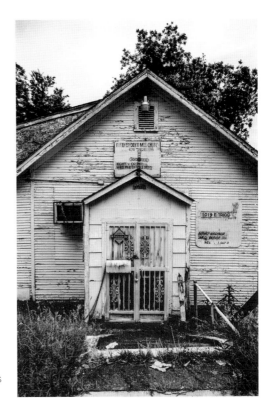

Abandoned Independent Missionary Baptist Church on Trigg Avenue. I searched far and wide for more information on this church, but had little results besides confirmation that the building does exist here.

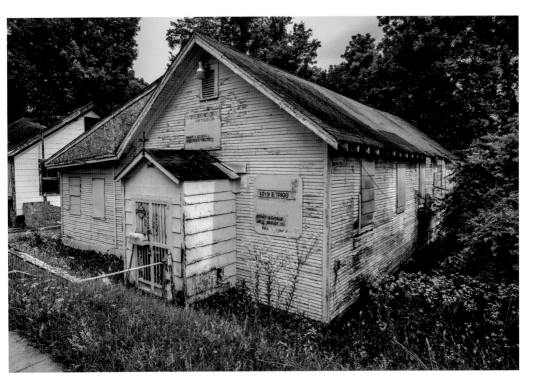

Another view of Independent MBC.

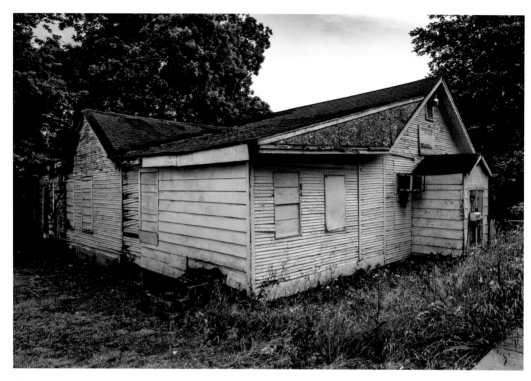

The rear end of the church looks like it was affected by the fire that took place at the home next door to it.

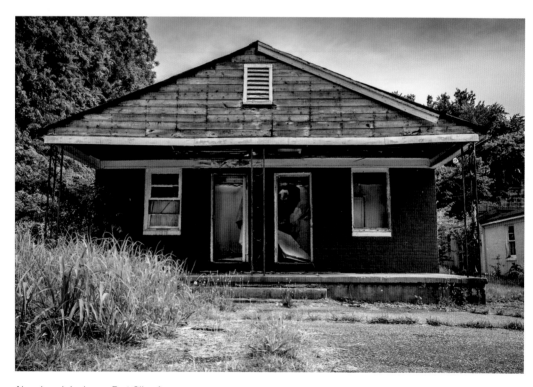

Abandoned duplex on East Olive Avenue.

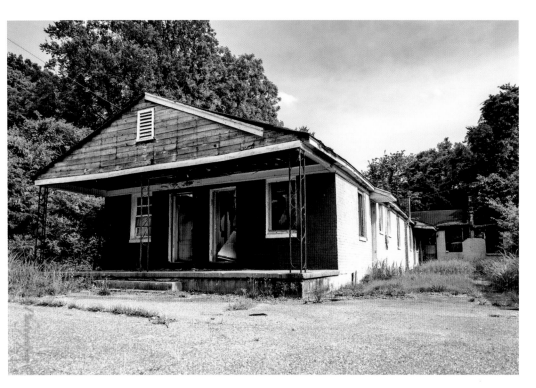

Side view of the duplex, or complex.

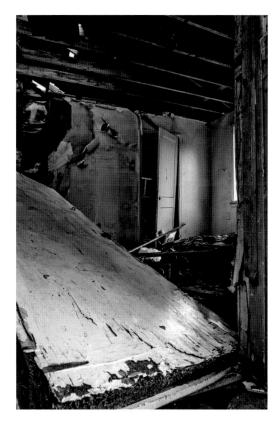

Wrecked interior of the duplex apartment.

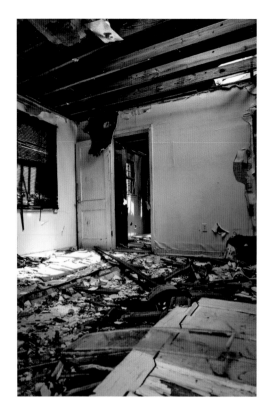

No floor to walk on here. Completely rotted.

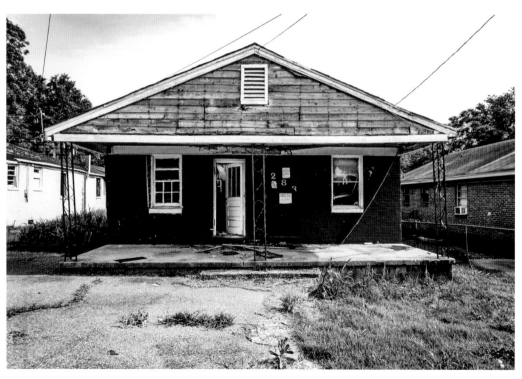

Another duplex right next door.

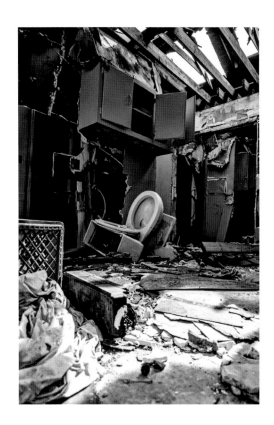

Couldn't tell where the bathroom ended, and the rest of the home began. Very confusing.

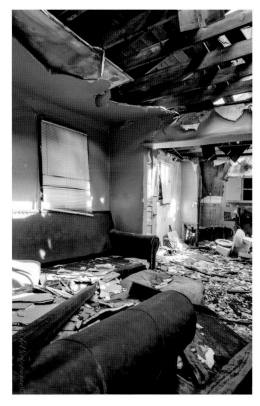

Cozy living room with lots of sun shining through the roof.

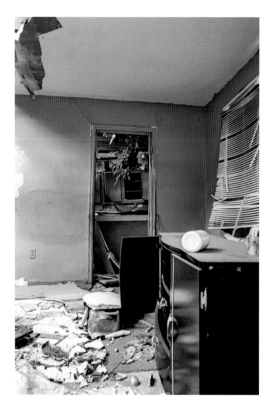

A bedroom and somewhat kitchen area.

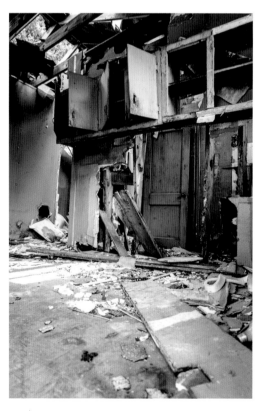

What's left of what may have been a work area in the back of the home.

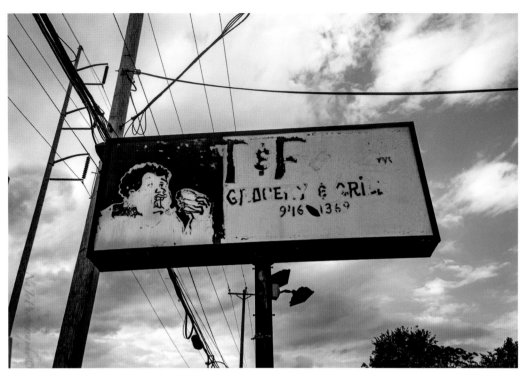

Hey hey hey! It's abandoned Fat Albert!! T&F (?) Grocery and Grille sign.

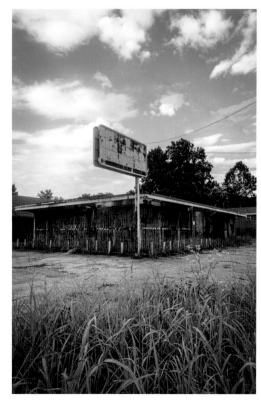

T&F (?) Grocery and Grille today.

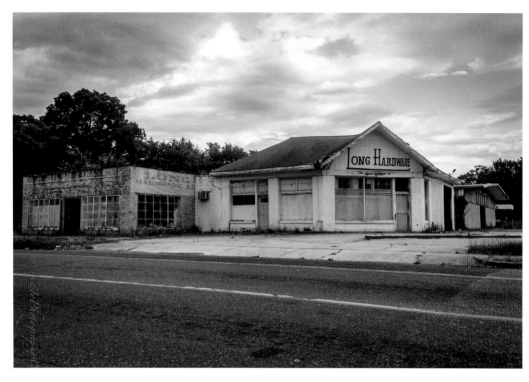

Abandoned Long Hardware Company.

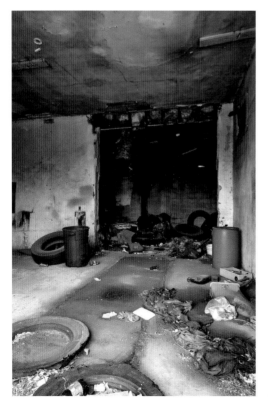

A peak inside of Long Hardware Company.

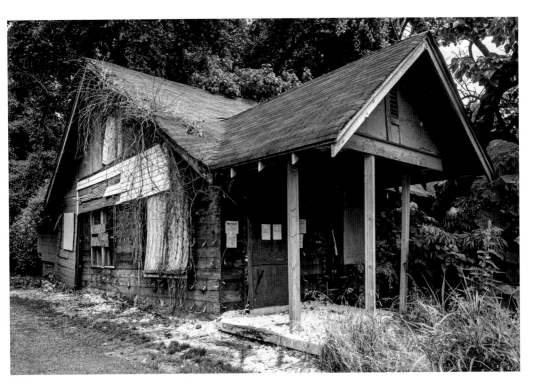

A condemned property on Coker Street. According to the notice it is due any day now to be demolished.

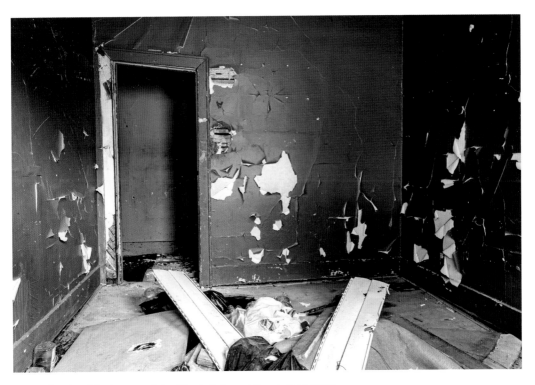

Interior of the home on Coker Street. Collapsed floor in the hallway.

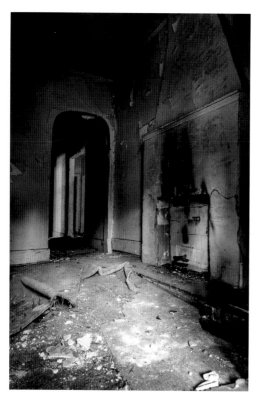

No living in this living room.

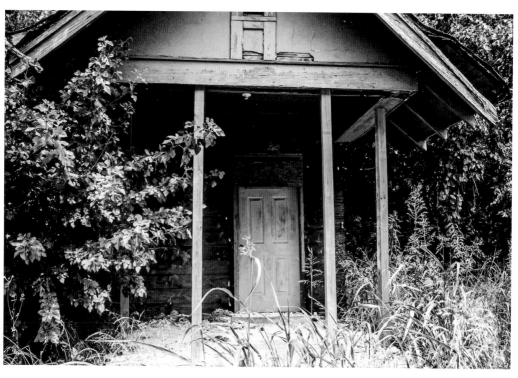

Exterior of the adjoining home on Coker Street.

3

HONORABLE MENTIONS

W. T. RAWLEIGH COMPANY WAREHOUSE

Built in 1912, this warehouse was once a big manufacturer of many common household goods until 1958. It shut down completely in 1970. It is located on the corner of Crump Street and Illinois Avenue.

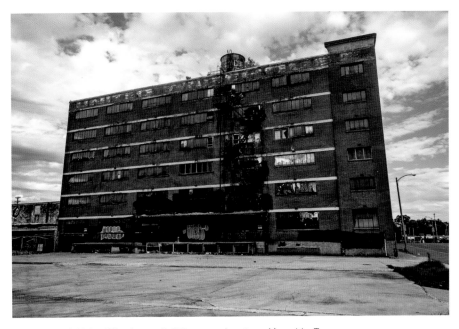

W. T. Rawleigh United Warehouse Building near downtown Memphis, Tennessee.

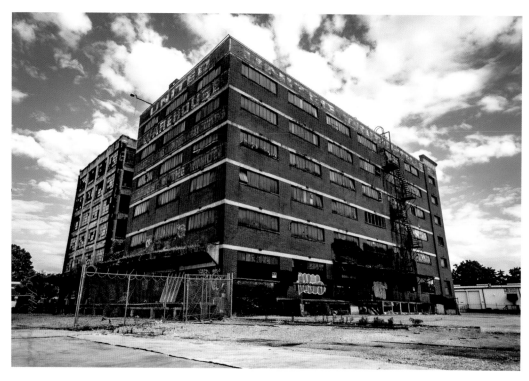

Rear view of the United Warehouse building.

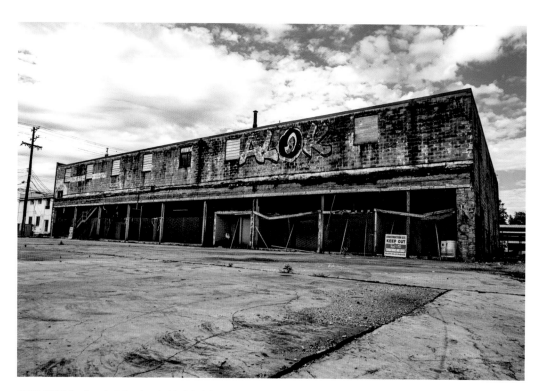

KEEP OUT! Another building located behind the warehouse.

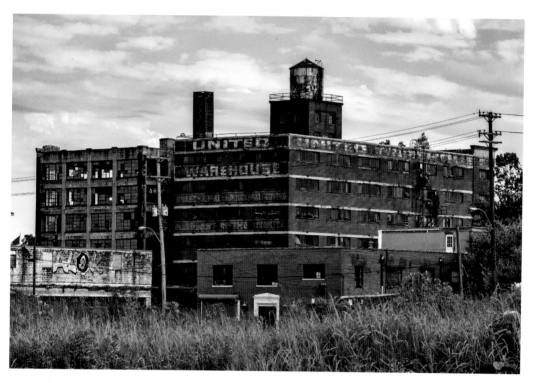

One last shot from across the railroad tracks.

United Equipment Building

First used as an animal feed mill called Wayne Feeds starting in 1951, this popular Memphis landmark (especially among urban explorers) has since transformed into a heavy equipment distributor, hence the name United Equipment. Though it has been abandoned for quite some time, a recent video on YouTube (youtube.com/watch?v=aE1ySatSjlw) dated March 10, 2018, indicates that this building is being primed for potential use as a brewery company. Showings of the facility are currently being scheduled, according to the realtors in the video. It is located on Lamar Avenue.

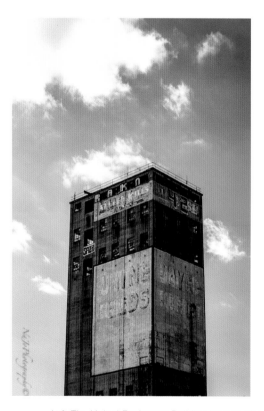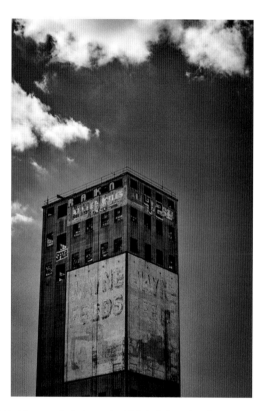

Left: The United Equipment Building located off Lamar Avenue. I photographed this in infrared so the former Wayne Feeds logo from the 1950s can be seen under the current one.

Right: Took another photo in black-and-white infrared for an even better look at the old logo.

Opposite page:

The Mid-South Coliseum. It has sat virtually silent for twelve years but may now be seeing some more use in the future.

MID-SOUTH COLISEUM

Opened in 1964, the massive Mid-South Coliseum located in Midtown off Southern Avenue was once the main performance arena for Memphis, Tennessee. Its approximately 24,000-square-foot arena floor has displayed the performances of countless greats including The Beatles, Elvis Presley, Rod Stewart, and more! In addition, the coliseum was well known for the professional wrestling matches held there and was the home of the University of Memphis Tigers basketball team.

Sadly, in 2007, the Mid-South Coliseum was closed due to the fact it was operating at a giant financial loss by this time and it was in need of very costly renovations to make it more accessible for those with disabilities.

For twelve years, the coliseum has sat virtually vacant, being used mainly as an enormous storage facility for the City of Memphis. At one point in 2015, there were talks of demolishing it, but the Coliseum Coalition has been successful at regaining interest in the historic property, so this idea seems to have been scrapped.

As recently as May 2019, the Coliseum Coalition put together a group of volunteers to do a one-day cleanup of the massive performance arena. This cleanup was done to make room for potential future performances to return and bring life back into the coliseum that brought so much life and entertainment to all of those who were blessed to witness an event there.

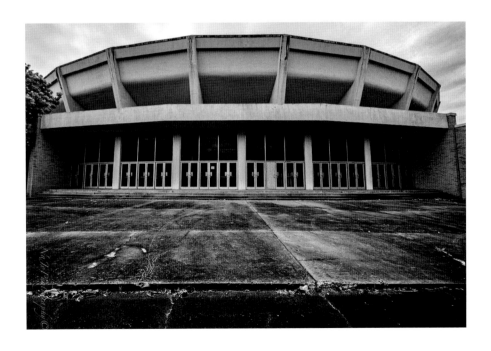

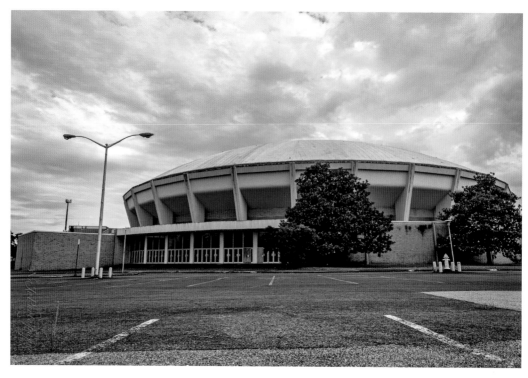

Another look at the historic Coliseum.

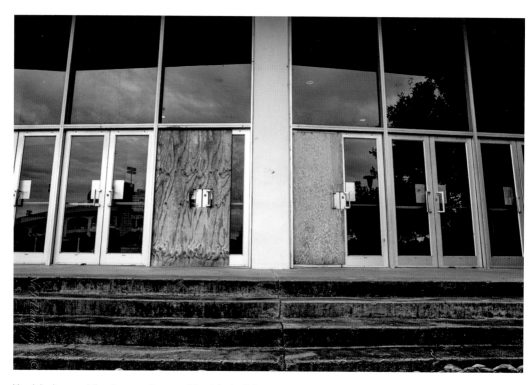

Vandals damaged the doors on the rear side of the building.

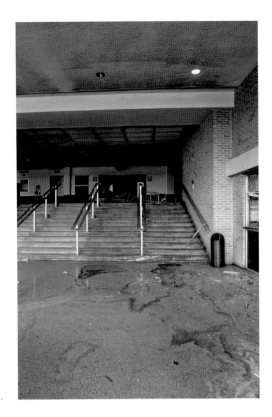

Box office area. Sad to see it like this.

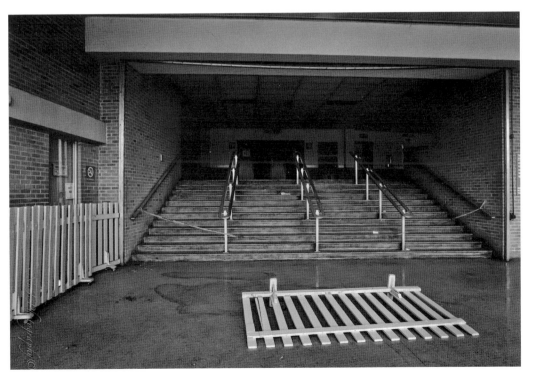

Another box office area.

THE WONDER BREAD FACTORY

Built in 1921, the iconic Wonder Bread factory in downtown Memphis had been vacant from 2013 until 2017 when the Orion Federal Credit Union announced plans to move in to the cornerstone property. Signage for the new credit union is now up and it is opened for business.

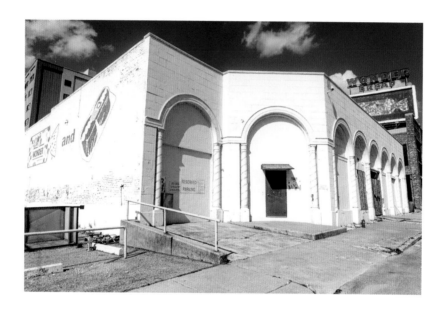

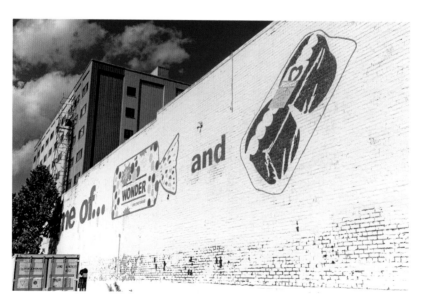

THE STERICK BUILDING

Completed in 1930, the Sterick Building was once labeled the "Queen of Memphis" as it was the tallest building downtown until 1957. Sadly, the state of the building began to decline in the 1960s and tenants began to move out of the amazing structure. Though it was placed on the National Register of Historic Places in 1978, the Sterick Building has sat vacant since the 1980s.

Many urban explorers have ventured in and gotten some incredible images. Paul and I tried looking for some sort of an entrance, but it is locked tight now, unfortunately.

There doesn't seem to be any plans to revamp the building, mainly because it needs extensive work to get it up to current code and that would cost the city, or whoever wants to take this on, millions of dollars.

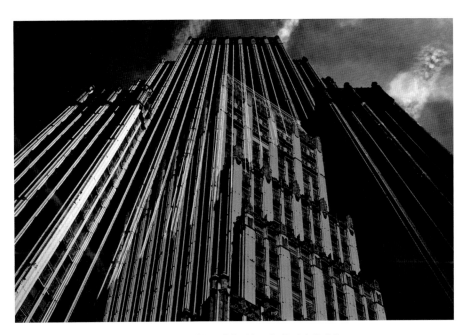

My double exposure black-and-white rendition of the historic Sterick Building.

OPPOSITE PAGE:

Above: Old Wonder Bread Factory. I can smell fresh-baked bread just from looking at this building.

Below: A closer look at the deliciously decorated side of the former factory, now converted to Orion Federal Credit Union.

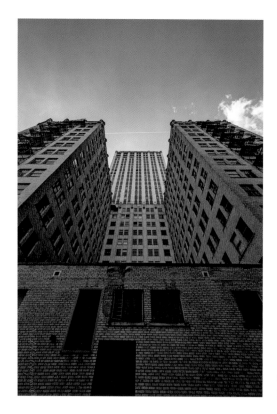

View of the back of the Sterick Building.
Imposing to say the least!

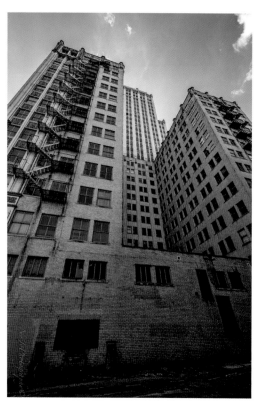

An angled rear view. As we were taking pictures,
we searched for a way in that was feasible, but
to no avail.

100 NORTH MAIN BUILDING

100 North Main is the tallest building in Memphis, Tennessee. Completed in 1965, it stands at 430 feet and has thirty-seven floors. It also boasted a rotating restaurant on the roof.

Due to the declining demand for commercial office space in the downtown Memphis area, 100 North Main was only 30% occupied by the year 2012. It was formally declared condemned in late 2015. Former owners did try to revitalize the enormous property by attempting to convert it into apartments or a hotel, but these have all failed due to the huge undertaking of getting the building up to current code.

As of January 2018, there are new owners. Townhouse Management Company, based in New York, has announced plans to convert it into a Loew's Hotel, also to include 220 apartment units.

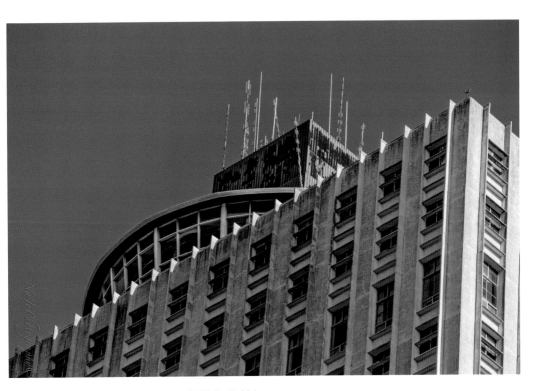

The revolving restaurant on top of 100 North Main.

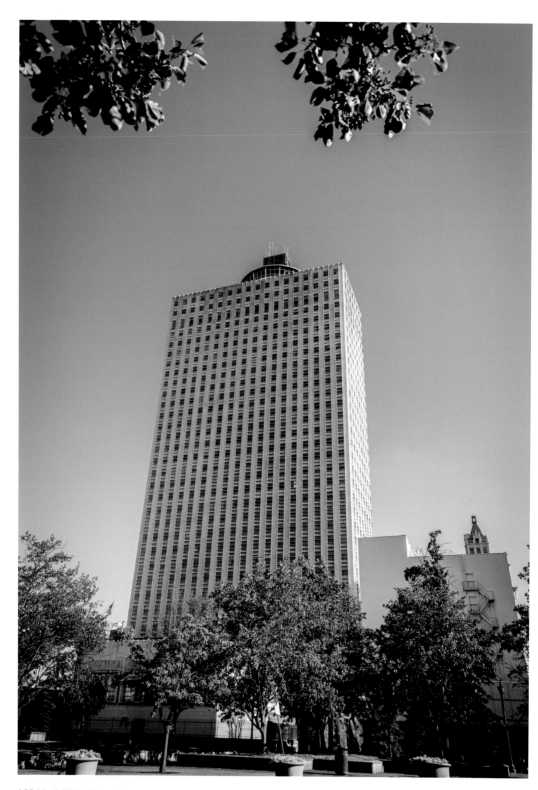

100 North Main. The tallest building in Memphis, Tennessee. Placed on the National Register of Historic Places in 2015.

ACKNOWLEDGMENTS

A lot of this would not be possible without my exploring partner, and friend, Mark Harbin. Thank you for risking your life right beside me, as well as all the fun we have on this roller coaster of a photography journey.

And of course, most importantly, none of this would have been possible without my love and photography teacher, Anthony Paul Harris. You bought me my first DSLR, a Nikon D2X. I have learned so much from you that I can take with me for the rest of my life. I love you.

Much love to my children: Nathan, age twenty-three; Jordan, age twenty-one; and Margeaux, age nine. All three of you, at one point or another, have suffered with me during these explorations. Ma loves all three of you. Know this forever. Thank you.

RESOURCES

bizjournals.com/memphis/news/2018/07/30/uptownsamerican-snuff-building-gets-historic.html

city-data.com/shelby-county/C/Chelsea-Avenue-9.html

encyclopedia.com/books/politics-and-business-magazines/armco-inc

facebook.com/EvangelicalFaith/

facebook.com/pages/category/Dance---Night-Club/Club-Envy-Memphis-254972884575800/

fox13memphis.com/top-stories/memphis-iconic-wonder-bread-factory-completely-renovated-with-new-tenant/955340509

highgroundnews.com/features/ColiseumCleanup.aspx

highgroundnews.com/features/thisplaceinhistoryiii.aspx

memphisdailynews.com/news/2018/aug/18/firestone-fallout/

memphisheritage.org/american-snuff-company-historic-district/

memphisheritage.org/st-thomas-catholic-church-convent/

roadsideamerica.com/story/34301

United equipment video: youtube.com/watch?v=aE1ySatSjlw

waymarking.com/gallery/image.aspx?f=1&guid=80389f8a-ce36-4cc2-9c0c-64f5c5fb93b6

wikipedia.org/wiki/100_North_Main

wikipedia.org/wiki/Mid-South_Coliseum

wikipedia.org/wiki/Sterick_Building

wreg.com/2019/06/04/orion-credit-union-moving-into-wonder-bread-development/